Janet Marshall
Septem

KU-196-923

BONNARD
AT
LE CANNET

To represent on a flat surface, masses and objects
situated in space - that is the problem of drawing.

Bonnard

Bonnard's plate-palette at Le Cannet

Michel Terrasse

BONNARD
AT
LE CANNET

Preface by Jean Leymarie

Including 14 photographs by Henri Cartier-Bresson

Thames and Hudson

Published with the assistance of the Conseil Supérieur du Mécénat

Any copy of this book issued by the publisher as a paperback is sold
subject to the condition that it shall not by way of trade or
otherwise be lent, resold, hired out or otherwise circulated without
the publisher's prior consent in any form of binding or cover other
than that in which it is published and without a similar condition
including these words being imposed on a subsequent purchaser.

Translated from the French *Bonnard et Le Cannet* by Sebastian Wormell

First published in Great Britain in 1988 by
Thames and Hudson Ltd, London
© 1987, Editions Herscher, Paris
© Spadem and Adagp for the works of Pierre Bonnard
© Henri Cartier-Bresson/Magnum
English translation © 1988 Thames and Hudson Ltd, London

First paperback edition 1992

All Rights Reserved. No part of this publication
may be reproduced or transmitted in any form or by any means,
electronic or mechanical, including photocopy, recording or
any other information storage and retrieval system, without
prior permission in writing from the publisher.

Printed and bound in Singapore by C.S. Graphics

Contents

Preface 7

Pierre Bonnard at 'Le Bosquet' 11

Works Executed at Le Cannet

The Côte d'Azur 33

The Garden 49

The Dining Room 57

The Small Sitting Room 79

The Bathroom 91

The Painter's Bedroom 101

The Studio 105

The Self-Portraits 115

A provisional list of works painted by Pierre Bonnard
in his studio at the Villa 'Le Bosquet' at Le Cannet
between 1927 and 1947 121

Photo Credits · Acknowledgments · References 127

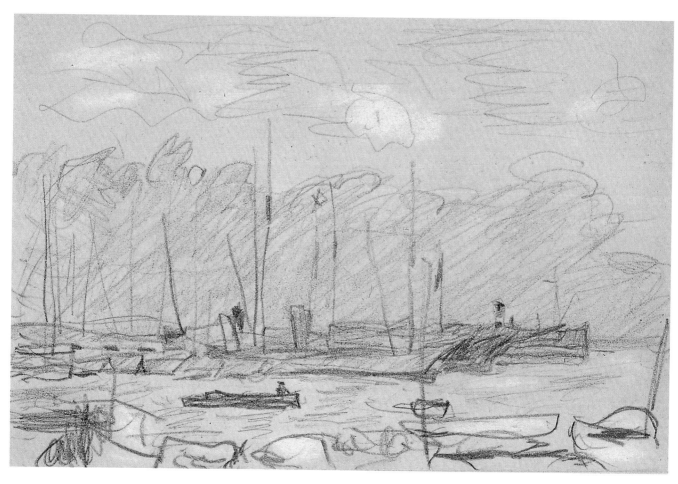

Le port de Cannes (*Cannes Harbour*), 1923. (13 x 17 cm). Pencil and white chalk.

Preface

IN JULY 1946 I had the good fortune to accompany Bonnard on his last visit to the Louvre, where I was working as an assistant. He looked at his favourite pictures without saying a word, peering at each of them separately, and glanced furtively though no less intensely through the broad windows overlooking the Seine. As he parted from me in the Place du Carrousel he made this revealing, often quoted statement: 'The best things in museums are the windows.' Almost the whole of his oeuvre is based on the window, that emblem of painting and symbol of visual activity. In the two houses he acquired in succession – the first in Normandy, near Monet, the other (the one we are concerned with here) in Provence – his first consideration was to introduce French windows with balconies or terraces.

I spent August at Cannes and shortly afterwards met the old master again, this time on his Mediterranean soil, in a gallery where some of his canvases were hung. He was very attentive, although he remained silent. To break down his reserve and hide my discomposure I told him quite suddenly that his colours were more radiant in the bright light of the Midi than under the Paris skies, where I had seen his recent exhibition at Bernheim's. 'Oh! do you think so?' he replied, with the gentle smile that the initiated have for the layman. 'Painting is much more difficult.' His own painting is as mysterious as it is familiar.

AFTER THE LONG INTERRUPTION of the war I was one of a small group of young people on holiday on the Côte d'Azur, which was then a glorious place, without any cars or tourism. Bonnard would sometimes come to join us on the beach, near the harbour, to watch us playing games and to gossip with the flower- and candy-sellers, from whom he would occasionally buy something. One Sunday a party was held in his honour on the Îles de Lérins. He was surrounded by about fifteen guests, who were struck by his kindness and unaffectedness: his niece, his dealer, other painters, a poet, an admirer, two graceful teenage girls, whose company he enjoyed without any hint of impropriety, and the Swiss art historian who wrote a whole book about that day. I can still see, in the halo of memory and the radiance of summer, his delicate movements, the way he swam apart from the rest of us, his thin ascetic body under the burning sun, the way he walked among us with quick, muffled steps on the dry twigs, his senses alert as he breathed in the different scents and felt the transparent

texture of the air, the expert way he sampled the meal, the way he napped lightly under the pines, with his eyes half closed and half watching. I can still hear his precise voice over the years, the rhythm of his conversation, restrained, subtle, and extremely exact. Recalling his past, he spoke to me of his excursions with Lautrec, his visits to Renoir, the atmosphere of the *Revue Blanche*, and the benefits he had gained from the practice of colour lithography.

I PAID TWO VISITS to his hermitage at Le Cannet, which is brought to life in this book – the little pink house nestling on high among the trees, a modest place in spite of the magical world that emanated from it. What painter has managed to render and invest his surroundings, both inside and outside the house, with more charm? The first occasion was an outdoor luncheon at the round table in the garden to which four of us were invited. Rationing was still in force and, although he himself no longer drank, he opened a bottle of the best wine as a surprise for us, rubbing his hands, pleased that we were happy – and aware of the Cézannian form of the receptacle and the Venetian colour of its contents. *La bouteille de vin rouge* (*The Bottle of Red Wine*) was the title of two still lifes painted in 1942, and the motif reappeared in his last, splendid interior, now in the Mellon Collection, which was started earlier but completed at this time.

He showed us the nooks and crannies of his garden, the lush tapestry of plants and birds unfolded in his work with the passing seasons, dwelling on his fragrant landmarks: the mimosa in January, the almond tree flowering a little later ('Every spring it forces me to paint it'), the fig tree in October. At one point in our walk, when I was behind him near the fish pond, I uttered in indirect homage to the greatness he had achieved in his old age, the sovereign name of Titian. Bonnard turned round softly and, misunderstanding the praise – which he would not have accepted – and thinking that we were speaking of the painters he admired, he quietly corrected us: 'Oh no! Not Titian, he's too tragic, but Veronese.' Veronese is the colourist of pale harmonies who fascinated Delacroix and Cézanne, and whom Ridolfi, one of his first interpreters, declared had 'increased joy and made beauty sumptuous'.

On the second occasion I had won his trust and was welcomed into his home and studio. One entered the only room on the ground floor, the dining room, every inch of which he painted from every angle, the baskets and bowls of fruit immediately visible on the tablecloths, and the silhouette of a person – or cat – which was harder to make out. At the time it was decorated with the Japanese woodcuts once bought for a few francs in the stores on the boulevards, and with the two canvases he received in exchange from Matisse, his friend and neighbour. The blue one was seen to best advantage in the daytime against its ochre background, while the red one looked its best at night. Near the straight staircase leading to the upper floor he had placed, as a kind of testimony, his small, obsessive study of a rose off balance which, he explained, he was continually doing his best to recentre by the accumulation of paint. The rose is the closest equivalent to the female flesh which he glorified in the tiled bathroom. His iridescent nudes, the most beautiful of the century, are caught unaware, floating like strange water-lilies or stretching their backs like cats, with the supple proportions of Hellenistic sculpture.

On the bedside table in his austere bedroom he showed me his secret treasure, a school copy of La Fontaine's *Fables*, illustrated for himself alone in the narrow margins with his most concise and lively animal drawings, executed in pen, pencil and occasionally brush. The painter had a deep affinity with the fable writer; both were full of *bonhomie* in its truest sense – the expression of the marvellous in nature – thanks to their craftsmanship. The bedroom opposite had belonged to Marthe, his inexhaustible model who had never posed formally for him. It had been locked since her death in January 1942.

When I reached the studio, Bonnard, who had arrived before me, was already busy, 'his brush in one hand, a rag in the other'. He preferred not to use a palette, where the colours ran together, but put each colour on a separate plate. Nor did he work with an easel. There was a narrow space between the window – looking out beyond the roofs and palm trees on to the bay in the distance with the mountains above – and the canvases which, without any stretchers, were attached to the walls with drawing pins. Bonnard could never submit to the rigid restriction of the frame, with its pre-determined dimensions, on which other painters organize their compositions; he needed a fluid, open, adjustable area for his textures and centrifugal forces: 'I always like to use a generous canvas, larger than the surface I shall actually paint; in this way I can keep my options open.'

On that day he was working on a decorative variation on an old theme, the orange harvest. A woman, with bare legs and arms, rushes towards the tree with golden fruit, in a whirlwind of intense, wild greens, thrown on coarsely. I remarked to him that he was confronting difficulties with increasing boldness. 'But this time perhaps I'm going a little too far,' he apologized and his sharp eyes circled by the steel rims of his spectacles sparkled in his wrinkled face. 'It's still green, it's not yet light!' Indeed, in his work he brings colour, speck by speck, to a shining point where matter is transformed into light.

His daily walk to wherever his fancy took him was essential for him; it was his way of gathering from its source the pollen of space and the pith of time. Immediately afterwards he would jot down his sensations in his meteorological diaries, in a free and uncontrolled way. On returning to his studio he distilled his booty by his own personal methods, by the character of his touch and open composition. He knew how to preserve the freshness of that first vision, to offer to the moving eye a texture that is both shimmering and unified. 'A picture is a sequence of marks which join together and end up forming the object, the fragment over which the eye wanders without a hitch.'

The day before I left, when a month had passed by under his spell, Bonnard came to the beach. For a long time we walked together, without speaking, around the magnificent deserted bay as evening fell. At the moment of parting, as the sun went down in its glory behind the Esterel, and the sea had the same mauve shimmer that he depicted in his last works, he embraced me – in spite of his diffident nature – and said: 'The light has never been so beautiful.' The words fitted the majesty of the spectacle, the fervour of the sublime artist who spoke them, as he neared the end of his life. Dazzled by nature, his eyes could turn with the same enthusiasm to his painting and confirm its final apotheosis.

JEAN LEYMARIE

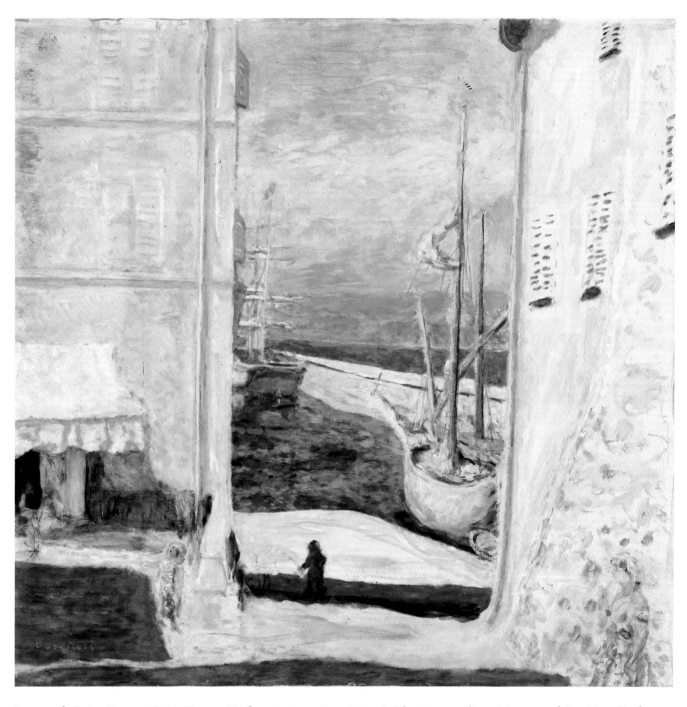

Le port de Saint-Tropez (*Saint-Tropez Harbour*), 1911. (84 x 86 cm). The Metropolitan Museum of Art, New York.

Pierre Bonnard at 'Le Bosquet'

To my father and mother

'Emotion comes in its own time,' Pierre Bonnard used to say.

All his biographers have noted the importance in his work of his discovery of the sun. They place this discovery in June and July 1909 during the painter's first significant stay in the Midi at Saint-Tropez.

Yet Bonnard had previously visited Spain, then Algeria and Tunisia.

Destiny no doubt decreed that it was to be in France alone that this poet was to discover his links with the universe; that he would always need a certain familiarity with people and things to express their essential nature.

And indeed, it was in the exquisite fishing village which Saint-Tropez then was that Bonnard made his discovery of bright light. The Orient of Sheherazade remained foreign to him, but here, in this simple little azure-bathed port, he received what he called 'a touch of the thousand and one nights'.

Under the blazing sun, with the mistral blowing, his palette caught fire without losing any of its subtlety. A born colourist, he was sensitive not only to bursts of colour but equally to the quality of the air, to the vibration, the texture, the perfume of things: a red varies depending on whether the weather is cold or warm, a yellow is different depending on whether it comes from a dress or from a mimosa.

He was captivated by this coast and returned practically every year from then on to Saint-Tropez, or to Grasse, Antibes, Cannes or Le Cannet. Each time he rented a villa: Villa 'Josephine' in Saint-Tropez, Villa 'Antoinette' in Grasse, 'L'Hirondelle' ('The Swallow') or 'Le Rêve' ('The Dream') in Le Cannet. He did not require them to be stylish, but they had to open on to a garden and overlook the sea. At Saint-Tropez he ran into Henri Manguin and Paul Signac and took part in their trips out to sea. When he was near Cagnes he would often go to visit Renoir, 'at the end of the day so as not to interrupt his work'.

Whether he was on dry land or out at sea he always had a pencil and a few sheets of paper in his pocket. The fishermen on the quayside unloading fish, the silhouette of a cargo ship against the Esterel, the golden splashes of lemons and oranges, the dry bark of the palm trees, the curve of the fronds, Marthe in the sun carrying a cat in her arms, the flowering of the mimosas in winter or of the almond tree in spring, the triangle of a sail on the sea seen through the olive trees – all these he wanted to capture, and

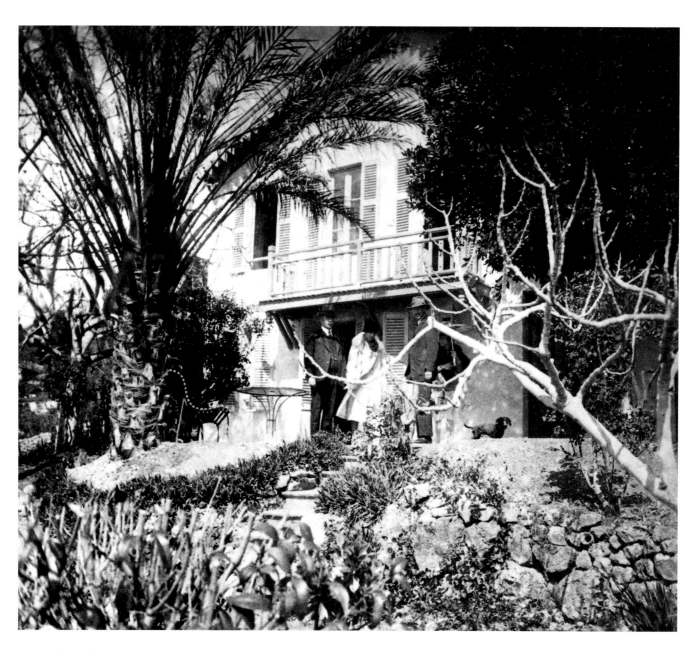

Dr and Mme Hahnloser at the Villa
'Le Bosquet' in 1927.

sometimes he would gather his impressions together in vast compositions full of life and fragrance.

But the day would come when, having had his fill of azure, he longed for changing skies and the sight of green pastures once more. Then Bonnard would go back to see his Normandy again. His thirst for nature was insatiable, his work in capturing life tireless.

It was around the 1920s, when the painter was on the Côte d'Azur, that he seems to have favoured the area round Cannes, and in particular the village of Le Cannet above the town. Was it as he strolled along the Avenue Victoria or on the surrounding hills in the course of his daily walk, with his two dachshunds following behind him, that he saw for the first time the pitched roof of the little house he was to choose?

He made up his mind, and 'on 27 February in 1926, in the presence of Maître Ardisson, notary of Mougins in the canton of Cannes', he bought the house described as follows:

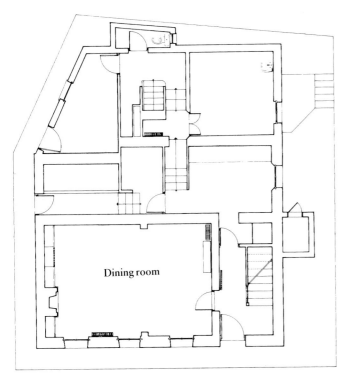

Ground floor

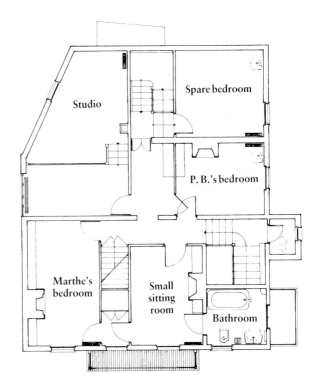

First floor

'A property planted with orange trees, containing a two-storey house and two reservoirs fed by the waters of the Canal de la Siagne, situated in the Avenue Victoria, Le Cannet, the said building located in the district of Le Bosquet.

'The present sale is consented to and accepted for the price of 50,000 francs, which the purchaser Monsieur Bonnard has now paid in cash, counted and delivered in the presence of the undersigned notary, to the vendors, who thank him and acknowledge receipt with thanks.'

Bonnard immediately christened this little house perched in a garden with stepped terraces supported by dry-stone walls 'Le Bosquet' ('The Grove'). With its pitched and pointed roof it had the air of a chalet (Bonnard's family house in the Dauphiné also had a pitched and pointed roof, as did his house at Vernonnet). He quickly set about enlarging it, giving it the necessary comforts and opening it out to nature.

He turned the two rooms on the ground floor into a single room. Two pilasters reveal the position of the former dividing wall – the painter enjoyed designing a Doric moulding for these pilasters himself. This was to be the dining room, which he opened on to the garden by adding French windows. Two more French windows on the upper floor led on to the balcony which he had added. On the north side he built his studio. Below the house he had a garage dug in the garden. He installed electricity, central heating and running water, fitted a bathroom with grey-blue glazed tiles, and put a wash-basin, mirror and cupboards in each bedroom. The walls of two bedrooms (including the painter's own) were painted pale blue, the cupboards in white. The walls of the dining room, the small sitting room and Marthe's bedroom upstairs were Naples

yellow. The inside of the glass-fronted cupboard in the dining room was painted red.

The furnishings, apart from two armchairs and some chairs in a pretty Provençal rustic style and some items of pine furniture, consisted of the wickerwork pieces that Bonnard took everywhere: tables and armchairs of cane or osier. On the mantelpieces were little yellow ceramic vases from Vallauris and some Provençal terracotta pots. On the dining-room table covered in red felt stood baskets with tall handles of plaited osier or raffia – somewhere to put the peonies and mimosa, the oranges, lemons and persimmons gathered, with the figs, from the garden.

The façade of the house was rendered with pink roughcast. The shutters, French windows and balcony were painted a light grey-green, as was the round iron table and the wooden bench in the garden.

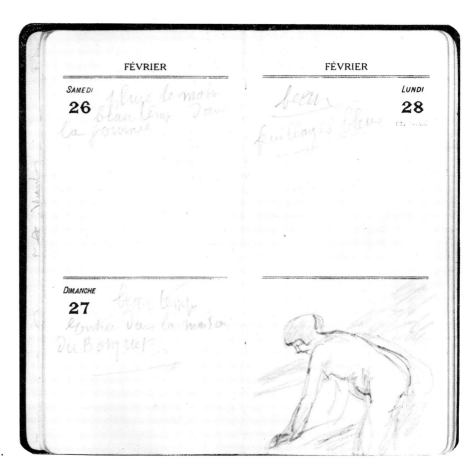

Pages from Bonnard's diary, 1927.

A stony path climbing up behind the house led to the little Canal de la Siagne, which ran across the fields and olive groves where herdsmen tended their goats.

Down below the painter could see the roof of his house beneath the silhouette of its palm tree, and further down the red roofs of Le Cannet descending towards Cannes. In the distance the mauve Esterel was outlined against the shining sea.

Bonnard moved into his house on 27 September 1927. In May of the same year, finding the garden too small, he acquired for 25,000 francs an adjoining piece of land on which an almond tree was in blossom.

Quite delighted, it seems, with his new home, he invited Henri Matisse to lunch and was able to receive his friends from Switzerland, Doctor and Madame Arthur Hahnloser. From now on 'Le Bosquet' was to be Bonnard's residence whenever he went to the Côte d'Azur.

He did not set up house permanently in the Midi but continued to travel between Paris, Vernonnet and Le Cannet. At the time he lived in Paris at 48 Boulevard des Batignolles. His studio was in the Rue Tourlaque, Montmartre, in the Cité des Fusains.

At Vernonnet, near Vernon, he owned a house called 'Ma Roulotte', also with a balcony and French windows opening on to a garden, which sloped down in terraces to the Seine where a small boat was moored.

It was not just the sudden longing for green pastures that made him leave Le Cannet. Marthe was always in a poor state of health and he was obliged to accompany her to various resorts: to Arcachon or La Baule. He also went to Trouville, where he enjoyed looking at the changing skies.

Bonnard always kept well away from other people and, if possible, on high ground, and so he chose Le Cannet rather than Cannes, Vernonnet rather than Vernon, Trouville rather than Deauville.

To travel in France from one place to another he used in succession a Renault, a Ford and a Lorraine-Dietrich, before buying a front-wheel drive Citroën.

He took the paintings he was working on with him from one house to another. Sometimes at Vernonnet he would finish a canvas begun during the long months at Paris or Le Cannet.

He did not transport them on stretchers (contrary to all convention, he painted on pieces of canvas which he then cut to the size that suited his purpose and fixed to the wall with drawing pins), but rolled them up inside each other and attached them to the roof of the car.

Indeed, a photograph taken in the villa Bonnard rented at Trouville in 1938 shows two canvases begun at Le Cannet, *Marthe à la corbeille de fruits* (*Marthe with a Basket of Fruit*) and *Le nu à la baignoire* (*The Nude in the Bath*), fixed to the leaf-patterned paper in the bedroom that he used as a studio. This means that the latter, now celebrated, painting crossed France from south to north and from north to south, exposed to the elements.

Thus Monsieur Bouin, the painter's Paris frame-maker, saw Bonnard come into his shop one evening and ask:

'Bouin, do you know what's happened? I was on my way back from Normandy, and as usual I'd tied my rolled-up canvases to the roof of the car. I don't know if it was braking hard or a gust of wind that did it, but they've gone!'

So in the 1930s, on the roads of Normandy between Trouville, Vernon and Paris, a few Bonnard paintings were scattered across the fields. Admirers of his work take note . . .

Only the war in 1939 could stop Bonnard travelling. He remained at Le Cannet until the end of hostilities.

BONNARD ALWAYS CARRIED around with him a few sheets of drawing paper and a diary.

Looking through the diaries that have survived, covering the years 1925 to 1946, the uninformed reader would be puzzled. Every day there is a note on the weather: 'Fine', 'Cloudy', 'Wind', 'Rain', 'Showers'. No doubt the reader would think this the diary of a farmer or a gardener or even a meteorologist, keeping an eye on the heavens.

There are many drawings striking for their spontaneity, life and often, despite their small scale, for their grandeur. Perhaps he was a draughtsman?

'Shirts, polish, gum, honey, cheese, soft soap': the list speaks of a man who lived alone and did his own shopping. Yet a woman is often depicted in a bath. She is also shown at table in the company of a dog or cat. So he must have had a wife, dog and cat.

He could not have seen anything of high society or spoken much: in twenty years there were just three reflections:

– 'The moment one says one is happy one no longer is.' (12 February 1939.)

– 'It is better to be bored on one's own than with others.' (4 September 1940.)

– 'He who sings is not always happy.' (17 January 1944.)

Did this person keep up with world events?

On 3 September 1939 the Second World War broke out: 'Rainy'!

There are precise notes: 'Weather fine but cool, there is vermilion in the orange shadows and violet in the grey ones.'

So was this man a painter, a particularly subtle colourist?

There are many drawings of flowers and fruit, and of boats. Did he live near a port? The sea is often visible, but in the far distance, through the trees. No doubt this man lived in a secluded place very high above the sea.

And the face which often appears in a mirror is surely his. How penetrating his gaze is!

On 26 September 1940 this man obviously met a goat, which he saw again under a tree on the 28th and 29th, and came across again on 3 October of the same year.

Next to the portrait of this goat is a rabbit with pricked-up ears. Was the rabbit drawn, like the goat, 'from nature'? In any case, it is clear that on 26 September in the year 1940 a painter was wondering why on earth nature had spread the ears of goats horizontally and raised those of rabbits vertically.

Pierre Bonnard was certainly hurt by the defeat of his country in 1940, and by the death of his brother-painter Edouard Vuillard in the same year. Most profoundly hurt. Yet Bonnard confided the secrets of his joys and sorrows to his painting alone.

The hateful German occupation, the division of France in two, the need to obtain the authorization of the occupying power to move from one zone to the other, the humiliation of his country – how could he not have been aware of all this?

The regular correspondence he started with Matisse reflects these torments and describes the difficult conditions which were imposed on daily life.

How could Matisse travel to Nice and Bonnard up to Le Cannet when there was no petrol? For a time Bonnard used to take a taxi down to Cannes twice a week to see the harbour. Soon that was no longer possible. Shortages of food meant rationing was introduced and having to go to the town hall to collect coupons for bread, milk or cheese. From then on it became a degrading task for a Frenchman to do his shopping.

Yet the diary continued to be filled with olive trees, goats, boats on the sea in the distance, notes on changes in the weather: 'Cloudy', 'Fine', 'Mistral'.

At 'Le Bosquet' Marthe's physical and mental health deteriorated still further.

Those close to Bonnard adopted the painter's discretion and reserve in matters concerning her, although everyone knew that what lay behind the visits to spas and changes of air which were constantly prescribed for her was a Marthe who had for years withdrawn into the narrow limits of herself. She could not bear anyone but 'her Pierre' and had created a void around him.

When Bonnard persuaded her to go on some walk, it was clear that the umbrella she carried was not to protect herself from the sun but to hide herself from others. When visitors climbed up to the painter's studio they knew that there was somebody in the next-door room. Sometimes a shadow could be heard walking.

Bonnard came across other faces, depicted other bodies, loved other women, but he sacrificed them to his painting. To part from Marthe would have been to part from his work.

In his paintings it is she who is present under the lamp, who reveals her body to the sun or bathes it in the water, who bends over flowers in the garden and gives the cat its milk. His 'pauvre Marthe' died on 26 January 1942.

Bonnard drew a little cross on that date in his diary, below the inscription 'Beau' ('Fine').

Now that Marthe had gone, he locked up her bedroom and never entered it again.

He valued the friendship of his kind neighbour Madame Charles Renaux, who lived at the Villa 'La Tany'.

He also valued the presence of Gisèle Belleud, a young girl he had agreed could come to his studio to work with him, so that he could advise her in her early career as a painter.

IN THE PAGES OF HIS DIARY Bonnard pondered creative activity 'under the sign of victory', 'under the sign of apathy', 'of energy', 'of acceptance', 'of uncertainty', 'of reserve'. . .

Among the anecdotes that Gisèle Belleud tells in her journal I would include this one under the sign of 'malice': in front of a canvas showing a *Nu à la baignoire* (*Nude in the Bath*) with a tiled bathroom wall in the background, Gisèle's mother questioned the painter about his supposed preference for small or large tiles: 'Well, yes,' he replied, 'it was when they were building the metro. Everyone was having to avoid the obstructions. Wanting to follow the others, I spun round and fell on the tiles!'

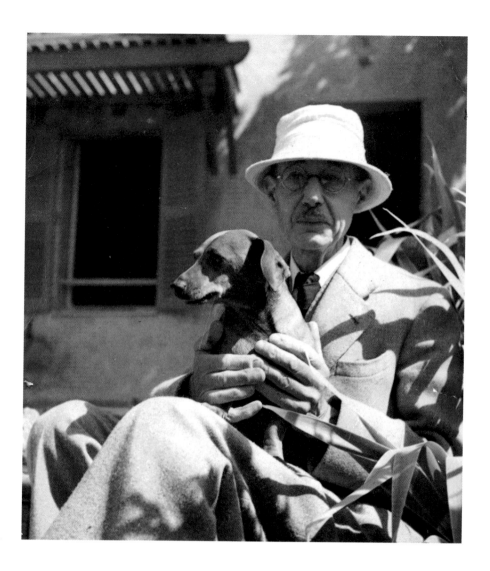

With Poucette in 1941,
photographed by André Ostier.

And this under the sign of 'naivety':

He complimented Gisèle on the cleanness of her palette compared with his own; his plate was laden with a mountain of colours which were impossible to scrape off.

'What are you going to do about it?' she asked.

'I've read that there is a splendid method. You pour some spirit on it and set fire to it so it burns. When the paint is burnt off, you put it out. It seems a perfect idea.'

The next morning she arrived at the studio. Bonnard was in a panic.

'What a stupid trick this way of cleaning a palette by setting fire to it is. The whole thing burned and I very nearly set fire to everything.'

This final anecdote under the sign of 'humility':

Bonnard was working on his *Saint François de Sales* (*Saint Francis of Sales*). He complained about not being able to integrate the figure of the saint 'into the background of the picture'.

'Why don't you put a little grey above his head?' she suggested.

Bonnard immediately prepared the right colour, climbed up on the stepladder – it was a very large painting – applied the paint, and declared himself satisfied.

He agreed to pose for his young colleague while he did her portrait; and since she had brought him violets in the morning, he picked some mimosa for her before seeing her off.

He also found consolation in the friendship of Matisse, who took a compassionate interest in Bonnard, his senior by two years. They managed to meet occasionally and they regularly exchanged news.

Matisse worried about Bonnard being uncomfortable in his 'garret', particularly because of the lack of heating – there was a shortage of coal and wood. He advised him – at least in winter – to take refuge in some grand hotel in Cannes.

Although he appreciated his friend's concern, Bonnard replied with a note of irritation that he was better off in his own little place, that he preferred his fruit-seller and tobacconist to the clientèle of the Cannes hotels, and that 'for the sake of a little material well-being I would lose everything that forms the basis of my existence, the constant contact with nature and my sort of work.'

Fortunately, as far as they were able, his nephews and nieces sent him food, Parisian admirers of his work arranged to have coal and wood delivered to him (he refused to use the black market). And his friends abroad also thought of him. But what of the inhabitants of Cannes and Le Cannet?

Only the postman knew that 'Monsieur Bonnard' was 'somebody': for more than twenty years he had brought him letters from Europe and the Americas.

Thus Bonnard was able to remain at 'Le Bosquet' undisturbed and climb up the stony path to the hills to meet his goats.

IT WAS IN DECEMBER 1942 – I had just passed my fourteenth birthday – that I first met Pierre Bonnard at Le Cannet.

My father, Charles Terrasse, had taken me on this first journey. It was during the war and yet the train, drawn by a beautiful steam locomotive, had a restaurant car. And so it was through the windows of a carriage in the blue and gold of the Compagnie Internationale des Wagons-Lits and the Grands Express Européens, near Anthéor in the red rocks of the Esterel, that I saw the blue of the Mediterranean for the first time.

From the glamorous town of Cannes a gasogene-driven bus took us along the Boulevard Carnot to Le Cannet. Having left our luggage at the Pension Rachel (the painter had been ill and two people looking after him were using his spare rooms), we climbed on foot between the red-tiled houses. We walked along sunny alley-ways running by the side of fragrant gardens in which lemons and oranges were glowing.

The light was like an illuminated manuscript as we arrived at the Avenue Victoria. We reached the green garden gate up a steep incline.

The devoted Antoinette let us in. In a few steps we reached the threshold of the house and the half-open door. Preceded by Poucette, his little dog, Bonnard floated downstairs to greet us with a big smile, his pyjamas, dressing gown and blue scarf hanging loosely about him. What eyes he had behind his small round spectacles! In a letter that was later found among

. . . when I saw you, through the half-open front door, coming quietly downstairs, swathed in your light-coloured dressing gown, with a blue scarf round your neck, I was suddenly made to think of some of your paintings, those snapshots that are so intimate and so characteristic of you . . .

Michel Terrasse to his great-uncle, 28 March 1943.

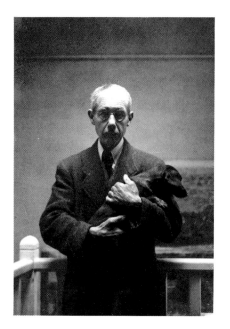

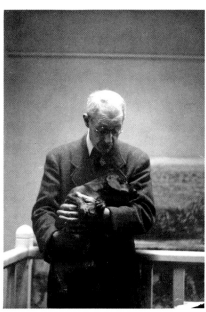

c. 1943.

his papers – he was kind enough to keep it – I told him how I recalled this first appearance. In the dining room I remember the red carpet, the yellow walls, the red cupboard with its glass front, some roses and mimosa in little yellow and green vases, Poucette lying in an armchair, and even the wireless on the mantelpiece: I was actually in a Bonnard painting.

There was only one thing I wanted to do: go up to the studio. My father had said to me: 'You know, your Uncle Pierre, he's very kind, but you have to take things slowly with him.'

It was only on the next day that I was saved from my predicament by the arrival of two exquisite girls, Madeleine and Suzanne, the granddaughters of Madame Renaux. They brought with them a piece of tart made by their grandmother, who always offered some to 'Monsieur Bonnard'.

They already had a foot on the stairs and they had hardly even looked at him for permission to go up.

'But of course, children, do go on up.'

What a disappointment we had when we arrived in the studio!

Instead of paintings, all we saw on the wall was an exhibition of the backs of canvases. At the age of seventy-five, finding that colour was 'going too well', Bonnard had turned the canvases the wrong way round to 'take up drawing again'.

I found the man we called Uncle Pierre rather intimidating. He realized this and one morning when I was beside him watching him paint in his studio, he suddenly put down his brush and rag. 'Come on, Michel,' he said, 'let's have a go at boxing,' and took up his guard.

Then I became bold enough to point out a painting of cherries that was pinned to the wall, and to ask him if the almost phosphorescent green of his signature wasn't intended to bring to the red of the carpet some of the green of the foliage in which the fruit was resting. 'Ah! You've seen that!' And he added: 'In every picture one has to have one or two strokes of inspiration.'

He was painting a small figure hanging out washing (in the painting entitled *Le toit rouge* [*The Red Roof*]) and was trying to obtain a particular white. Suddenly he turned to me: 'Michel, how do you make your whites?' This humility says everything about Bonnard.

He had seen some of my gouaches and even fixed one of them to the wall – it was placed alongside some of his own drawings, some reproductions of artists ranging from Vermeer to Picasso, two minuscule canvases by Renoir and Cézanne, as well as a quantity of sweet wrappers – he was fascinated by the reflections of these small silvered rectangles full of colours.

Once when I was looking at a figure by Picasso, he said to me, as he continued painting: 'That man's eyes aren't made like everybody's!' This comment was of course quite true, but its candour was comical, coming from a man who had himself been granted the ability to make people see what nobody before him had been able to.

Every morning Bonnard followed a fixed ritual. Whether in the Dauphiné, in Paris, Vernon, Trouville, or Le Cannet – wherever he was, he would set off for his morning walk before breakfast. Every morning, to provide inspiration for his work, he set off to get his fill of life.

The little Canal de la Siagne.

'Art will never be able to do without nature,' he wrote. And he added this comment, which I dedicate to all those who express the quintessential in life:

'When one forgets everything, all that remains is oneself. And that is not enough.'

At Le Cannet I did this walk several times with him. We would set off, followed by Poucette, and climb up through the hills above his house and along the little Canal de la Siagne. Through the olive, orange and almond trees we looked down on the red roofs of Le Cannet, Cannes and the sea.

One morning he suddenly stopped: 'I've seen these olive trees so many times, and they said nothing to me. But it rained last night, and their leaves are glistening . . .' He immediately took from his pocket a piece of paper, which he held in his hand, and a stub of pencil so short that it disappeared between his thumb and index finger, and drew this silvery vision. When we got back to his garden, before going back into the house, he turned and looked at the sea through the trees. He rubbed his hands, a familiar gesture which indicated a certain satisfaction, and said to me: 'This morning I'm pleased: I have found a quality of air and light again which I hadn't seen since Deauville ten years ago!' Then he fixed the new little drawing of the olive trees, this living trophy, to the wall of the studio. Finally he had breakfast, complete with marmalade.

He was constantly active – like a bee.

After supping the nectar of the hills above the house and of the flowers in the garden, after gathering his harvest in the baskets of fruit in the dining room, or capturing afresh one of Marthe's poses as she got out of the bath, he would move from one canvas to another in his studio, laying on colour.

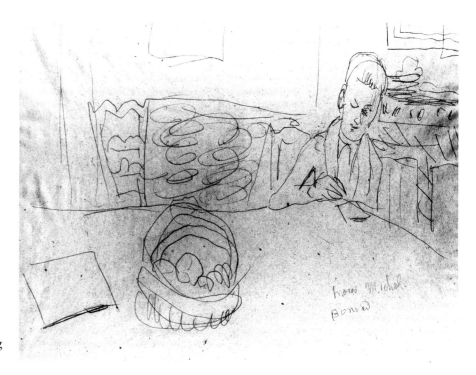

Michel Terrasse drawing in the dining room, 1943. Pencil.

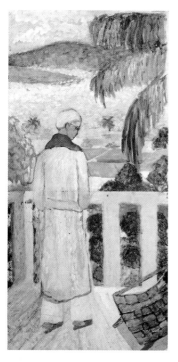

Bonnard sur son balcon (*Bonnard on his Balcony*), 1943. Gouache by Michel Terrasse.

He proceeded slowly, as if counting his steps, from before breakfast in the morning until after dinner. A number of his works were drawn, if not painted, by artificial light.

He proceeded patiently, casting his penetrating gaze on every being and thing, anxious to seize every sight.

If the floor of the dining room at Le Cannet were divided into squares and – as if playing hopscotch – one stopped on each square in turn, one would discover a subject he painted.

The same experiment could be carried out on the first floor, in the small sitting room, the bathroom, the studio.

It could be done in the garden, and on a larger scale in the Avenue Victoria and in the surrounding hills.

The richness of this painting – everything is inviting, right down to the cherry stones on a plate – is partly the result of a compulsive way of looking at things, a kind of avarice, like the avarice of the ant.

In Bonnard nothing is lost, everything is re-created.

When he had finished his work session he liked to go down to the bottom of the garden before lunch to 'say hello' to Agenor, the goldfish, in its pool. Agenor had once had a companion, and they can be seen in a wonderfully luminous canvas.

On returning from the garden he stopped on the threshold to the dining room: 'In *La salle à manger* [*The Dining Room*], which I'm painting at the moment, I'm trying to do what I have *never* done: give the impression one has on entering a room: one sees everything and at the same time nothing.'

After the meal – I tasted olive oil for the first time – I sat down at a corner of the table and drew. When I lifted my head, Uncle Pierre was handing me with an amused smile the drawing he had just done of me; I hadn't noticed anything.

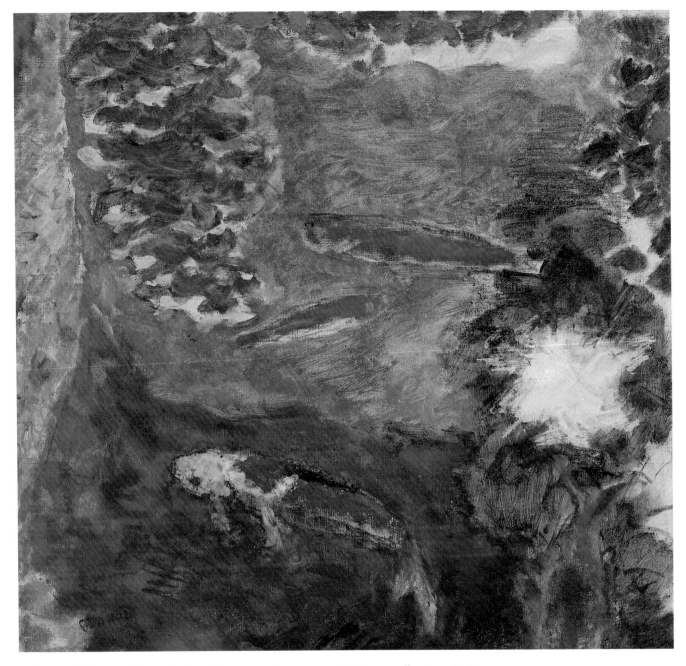

Le bassin d'Agenor (Agenor's Pond), c. 1943. (43 x 50 cm). Private collection, Paris.

In the afternoon, before returning to the studio, he had a nap. I went into the garden to draw and paint.

One day one of his friends was going to see Matisse at Vence, and my great-uncle asked me if I should like to go with him . . . 'Hello! Matisse, it's Bonnard. My great-nephew would like to make your acquaintance.'

A beautiful young woman called Lydia welcomed us: 'Yes, the Master is expecting you. The Master will receive you.' I shall never forget our arrival in the house of the Master of order and clarity which was decorated with oriental fabrics, nor my return to the little house of the painter of quivering light.

After dinner we would sit, Bonnard, my father and I, in front of the hearth. Poucette would be on her master's knees. Every evening I drew Bonnard by the fireside – drawings I regret having destroyed. My friend Claude Bergogne has kept the gouache I painted of my great-uncle on the balcony of 'Le Bosquet'. I also painted a gouache of the garden by night – I already liked to paint the light of dusk and night.

Every evening – I can still hear him – Bonnard would say to my father: 'Charlot, we must have a serious talk. One day you will be a picture dealer . . .'

He was worried about the fate of his works and wanted to put his affairs in order. My father could not even bear the thought that his uncle might no longer be with us and would straightaway assure him that he looked 'in the pink of health', hum Renaissance tunes and speak to him about the mistresses of Francis I.

From 1942 onwards – was time now pressing? – many visitors, from France and abroad, arrived at the Villa 'Le Bosquet': art historians and critics, publishers, photographers, admirers, painters, journalists, museum curators and dealers.

Three books were written about him.

Four reviews appeared, periodicals devoted whole pages and special issues to Bonnard. He was asked for interviews. People wanted to record his remarks on painting.

In a reply to the weekly *Comoedia*, he made a distinction between decoration and painting done with feeling, and described the painter of feeling as 'an artist whom one imagines spending a lot of time doing nothing but looking around him and within himself. He's a rarity . . .' Bonnard was celebrated in articles, reports and photographs.

Yet nothing could affect his modesty.

One day he said to Pierre Courthion: 'Oh yes, I'm fully aware of it. I can quite feel there is something in my painting. But to plug it like this! . . .'

Even the presence of photographers, the clicking of cameras, did not distract this 'celestial reporter' (in André Lhote's charming phrase) from his work.

In July 1945 the painter returned to Paris for the first time since 1939. He visited his nephews and nieces, his friends and Misia; he saw his studio in the Rue Tourlaque again, and went to the galleries. He stayed at the Hôtel Terminus near the Gare Saint-Lazare and drew the Place du Havre, which he could see from his windows, and the comings and goings of the passers-by, the buses, the grey iridescence of Paris, which he now redis-covered.

On his return to Le Cannet he was accompanied by his niece, Renée Terrasse. She was to stay by his side from then on.

Every morning he set off to rediscover nature. In his studio, moving from one to another, he loaded his canvases with ever more brilliant colours.

He 'raised his voice' and agreed with the Primitives who looked for azure blues and the most fiery reds in precious materials: lapis lazuli, gold

and cochineal. Some of his canvases radiate freshness like a living rose; in others he has given his subject matter a new depth, as if he wanted to take the world in his hands.

At the Villa 'Le Bosquet' the flow of visitors continued, their admiration aroused by these radiant works. The announcement of one particular visit filled Bonnard with joy: that of the Chief Curator of the Musée National d'Art Moderne. He gathered together a selection of his most recent canvases which he considered the best. The man from the museum arrived – and did not take any of them. 'Non-figurative' art had already begun to hold sway . . .

The old man was upset. Courageously he again took up his work, his 'consoling work', as he called it.

A few weeks later Jacques Dupont, a high-ranking official at the Beaux-Arts who liked Bonnard's work, visited his studio. Bent over his canvas, Bonnard was painting, 'brush in one hand, rag in the other'. Jacques Dupont looked at a gouache which he had picked up. 'How beautiful it is!' he said. Immediately Bonnard turned round: 'You think that's beautiful?' Without putting down his brush or rag, he snatched the painting away and tore it to pieces.

Then he turned back to his picture.

Jacques Dupont was dumbfounded and distressed; it was only years later that he discovered the reason for this action: the wound still festered.

On the wall of the studio, the *Corbeille de fruits* (*Basket of Fruit*), the *Nu au basset* (*Nude with a Dachshund*) and the *Bouquet de mimosas* (*Bunch of Mimosa*) were enriched daily with new colours. What Claude Roger-Marx has called Bonnard's 'gift for wonder' remained intact.

This power of being present every day at the birth of the world is not naivety.

Imagination and the cheerful discoveries of his early years had been succeeded by a new fervour.

Though he felt with all his being that spring would come again, he knew that in all his being winter was setting in. In his last self-portraits Pierre Bonnard's lucidity is deeply moving – and frightening.

From 27 June to 21 July and 7 to 20 October 1946 he stayed in Paris for the last time.

Jean and Henry Dauberville devoted their first exhibition after the war to him.

He came to Fontainebleau to have lunch with his family. His *Cheval de cirque* (*Circus Horse*) hung on the dining-room wall behind him.

Was it that evocative horse that had summoned him?

At the end of the meal he went up to it, asked for a stepladder, and applied some touches of dark blue and black at the top of the picture.

I asked him some questions.

About drawing:

'You must draw continually so as always to have a repertory of forms to hand.'

About subject matter:

'You must never seek material for its own sake. Every true artist finds the subjects that he needs.'

About the future of painting:

'In the future one will have to know whether one is a painter-decorator or a painter of feeling.'

Pierre Bonnard went back to his little villa at Le Cannet. In the mornings, wearing his canvas hat, he climbed up along the stony path in the hills.

For as long as he was able he went from one canvas to another in his studio.

But his health was deteriorating.

Though bedridden in his austere cell, and drained of strength, he was still thinking of his *Amandier en Fleurs* (*Almond Tree in Blossom*).

He asked Charles Terrasse to bring him the canvas: 'This green – on the ground – there – it's not right. It needs some yellow.'

The nephew who loved him best took his uncle's hand and helped Pierre Bonnard to add a little touch of gold for the very last time on this earth.

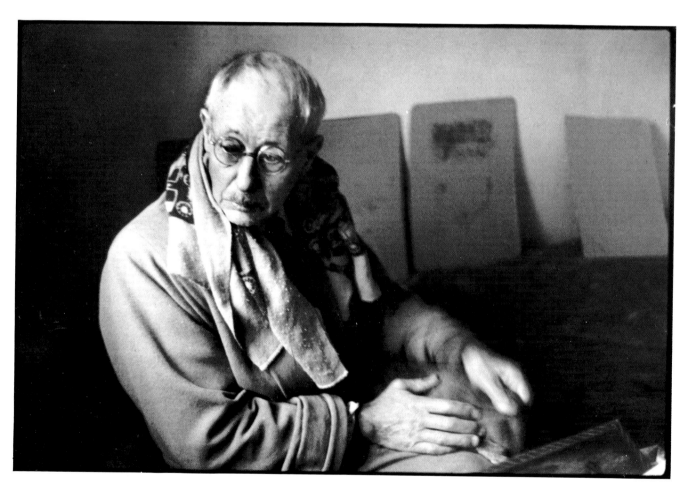

H.C.B.

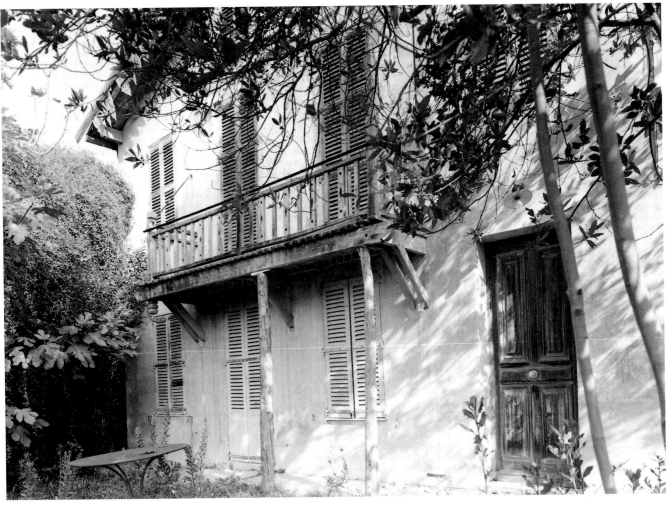

The deserted house.

SEVEN MONTHS AFTER THE DEATH of the painter on 27 January 1947 his estate gave rise to a lawsuit.

It was not provoked by disagreement between his heirs but by rivalry between two picture dealers.

One of these dealers failed in his attempts to split the family; they got rid of him.

He and his accomplice, the family's own lawyer, then went off to look for others who might have a claim on the estate. They found some who were delighted to learn that there was a painter in France called Pierre Bonnard, that he was a great painter, and that they were his indirect heirs . . .

There is a fable in which two mice find a piece of cheese and a monkey offers to divide it between them. Every time it is placed on the scales, one pan sinks underneath the unequal weight, whereupon the monkey restores the balance by swallowing the excess cheese under the very eyes of the stupefied mice.

In Bonnard's case, the lump of cheese, the inheritance, was considerable (it consisted of all the works left by the artist) – far too much for a single monkey and a pair of mice.

There were therefore very many monkeys, and they were all very devoted to justice.

27

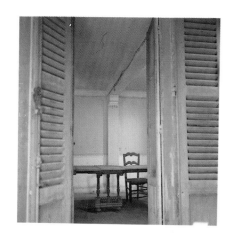

There were also many mice, and not all of them let themselves be deprived in this way. Some of the mice turned out to be voracious themselves, which only increased the number of the monkeys and the amount of work for them to do because of their devotion to justice – which, if it is to be good justice, must take a calm and measured course . . .

Twenty years later the lawsuit was still going on, until a settlement out of court put an end to the proceedings. Not that time had disarmed the combatants – but it had begun to reduce them in number.

The Villa 'Le Bosquet' was also sequestrated. While the painter's works were mounted on stretchers, sorted, measured, listed, numbered, counted and recounted, his little house and garden, which had inspired many of the most beautiful of them, were neglected.

For twenty-one years . . .

Every time I visited the Midi in the summer I would visit Le Cannet, climb the rocky slope above the house and follow the little Canal de la Siagne, retracing the old daily walk . . .

Down below, the abandoned house standing under the palm tree still overlooked the sea.

I would make a drawing of it to paint it on my return. Then I would scale the wire fencing and enter the forbidden garden.

Under the fig tree was the bench used for sitting at the rusty table, next to the closed shutters. Among the thick weeds the old roses still flowered, the pear tree still provided its delicious Saint-Jean pears. And the almond tree was still there.

The years passed.

'Visitors' less devoted than I was broke into the villa, smashing the boards of the shutters and damaging the doors.

I have lost count of the number of times it was burgled, turned upside down, violated.

The damage caused by burglars was aggravated by the ravages of time.

By 1959 the architect sent by the sequestrator declared that 'the walls and ceilings are cracked in all directions – the consoles of the balcony are rotten,' and decided that 'it is not appropriate to undertake considerable and expensive restoration work on a villa which any future owner would certainly think of demolishing.' The balcony was shored up.

The seasons continued to come and go, the weeds to climb higher, the damp to penetrate, the thieves to steal.

17 February 1966.

The architect wrote to the sequestrator:

'Dear Maître . . . The Villa "Le Bosquet" has again received a visit from burglars who have taken an iron bedstead (of no value) . . . Should a complaint be lodged?

'I draw your attention again to the state of dilapidation of the villa.'

The iron bedstead was of no value, but it was Bonnard's own bed from his austere bedroom.

28 August 1967.

'Dear Maître . . . some books and a vase have disappeared and the chandelier in the dining room is broken. All these are of no great value . . .'

My father protested.

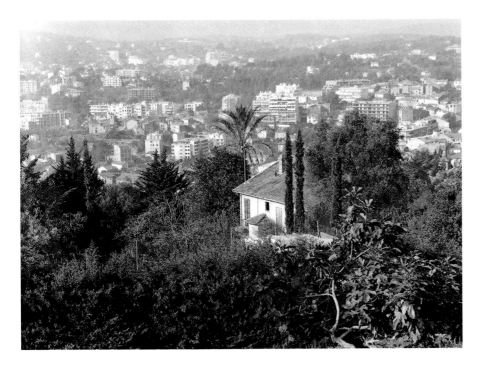

In 1967 . . .

But he was only one of the heirs.

Meanwhile in 1965 those members of the municipal council who were sensitive to Bonnard's memory – including Monsieur Gardetto and the faithful Gisèle Belleud – had named a street in Le Cannet after him.

Huts went up in the hills above the house. In the evening gangs of workmen would return from the building sites to their shacks up the hill.

The property boom ruined the Côte d'Azur.

The little canal was enclosed in black pipes. There were no more goats.

In the garden the small trees, the oranges and the lemons struggled valiantly but in vain against the shortage of water and the choking weeds.

Perhaps to escape this hardship, the palm tree began to grow dramatically, spreading its dejected fronds above the house like a distress signal.

The almond tree was still there.

In 1967 I wrote a film about the life and work of Bonnard, and took a French television team to Le Cannet. The great cameramen Bernard Joly and Jacky Kargayan, both admirers of his work, explored the house.

After twenty years of neglect, the table and the painter's Provençal armchair were still to be found in the dining room; the raffia basket and the little pots from Vallauris were still in the untidy red cupboard; his canvas hat was still in his bedroom wardrobe.

The studio still had the narrow corridor where he painted, and the bare wall . . .

They were moved as much by the simplicity and modesty of the house as by its state of neglect.

At last, on 13 August 1968, at the time of the sale by candle, my brother Jean-Jacques, in our father's name and in the presence of the notary Maître Bellon, bought Bonnard's little house for the sum of 210,000 francs.

It had been saved!

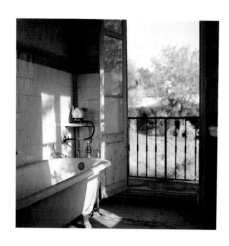

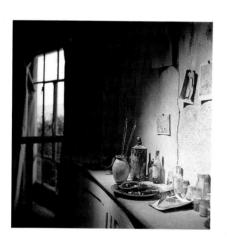

The house had to be completely restored. The work lasted many months and was carried out with the most scrupulous respect for the original arrangement, materials and colours.

The glazed tiles were restored to the bathroom walls. The bathtub with tiger's feet is the same one seen in the paintings of nudes bathing. The modest interior was only altered slightly: the bathroom floor was covered with new diamond-shaped tiling cut on the pattern of the linoleum that was there before, and a red velvet cloth replaced the old felt on the dining-room table.

Monsieur Louis Sorlier cleared the garden with a scythe and brought it back to life.

The house had been rescued! . . . But had it really?

It had been saved from neglect; now it had to be saved from concrete.

The neighbouring Villa 'La Tany' had been demolished and in 1973, without warning, a five-storey block of flats rose in its place and loomed over the house.

With their usual sensitivity the developers constricted and cut off the little path leading to the front door of 'Le Bosquet'. The slope was so steep that we demanded that the developers and the municipality (the path is a public by-road) build some steps: but these have proved unsuitable for anyone who is not an acrobat or a would-be suicide!

From then on the entrance to the house has been through the garden and one has to climb fifty steps to reach the doorstep.

In the same year, 1973, we learned that it was now the turn of the other villa flanking 'Le Bosquet', the beautiful 'Isola Serena', to be demolished, and I took measures to have Bonnard's house listed.

Knowing that these proceedings were in progress, the prefect of the Alpes-Maritimes department decided to postpone permission to build on the neighbouring site (16 May 1973). However, the mayor of Le Cannet – himself an estate agent – took advantage of a temporary vacancy at the prefecture and signed the permit on 28 March 1974 . . . Thanks to the understanding of Monsieur Sibelli, an assistant at the Ministry of Development, I managed to have the planned building moved about seventy feet. Consequently the garden of the villa now opens on to the beautiful grounds of the new block, the hills and the sky.

After reading the report drawn up by the *Conservation régionale des Bâtiments de France* at Aix-en-Provence, and in particular by Madame Audibert, the *Commission supérieure des Monuments historiques* decided to include Pierre Bonnard's house in the supplementary inventory of the *Monuments historiques* on 28 October 1974 (the ministerial order was signed on 5 May 1975).

Being the owner of a listed building sometimes has its surprises. One day my father received this letter from the Office of French Radio and Television (ORTF):

'Dear Sir, I have the honour to inform you that the second television channel of ORTF has included a programme devoted to the Impressionists in its schedule. To evoke the life of Van Gogh I should be very grateful for your permission to do the filming in your house at Le Cannet which once belonged to Dr Bonnard . . .'

This letter was signed by the administrator of the 'Creative Documentaries' service. What a brilliant piece of documentary making!

Bonnard, however, would have been flattered by the title of doctor and especially by being confused with Van Gogh, whom he greatly respected. Perhaps Van Gogh would have recognized Bonnard as the painter he described in a letter to his brother Theo on 5 May 1888: 'But the painter of the future will be a colourist such as has never yet existed. Manet was working towards it, but as you know the Impressionists have already got a stronger colour than Manet. But this painter who is to come – I can't imagine him living in little cafés, working away with a lot of false teeth, and going to the Zouaves' brothels, as I do. But I think I am right when I feel that in a later generation it will come, and that as for us we must work as we can towards that end, without doubting and without wavering.'

Today.

Cleared of the weeds and undergrowth which had smothered it, the garden now had to be replanted, and, in order not to have to wait too long to see fruit on the branches, full-grown trees were planted.

How were these trees to be heaved up the fifty steps? The magnolia which was to replace the fallen laurel in front of the house weighed nearly a ton. The steps could not support it, and it would have been too much for the workmen to lift.

The tops of the cypresses at the end of the garden were too high.

We had to call in the tallest lifting equipment on the Côte d'Azur and transform the second terrace of the garden into a landing platform!

The magnolia, olives, eucalyptus, orange and lemon trees and mimosas, together with the white and red laurels, the flowering rose bushes, wistaria, honeysuckle and jasmine, followed by supplies – peat, manure, compost – arrived in the garden by air over the tree tops.

They were joined by three olive trees donated by the new municipality of Le Cannet, as well as peony shrubs, and, from Loiret, 'Star of Holland' roses which smell delightful – something to put in the bow-handled flower basket and the terracotta vases.

If Pierre Bonnard were to return to earth in his canvas hat, he would recognize his house.

The wall in the studio awaits him intact.

In a few weeks the almond tree will be in blossom again.

What would one read in the pages of his diary for Saturday, 28 February 1987?

'Fine.'

'Returned to Le Bosquet.'

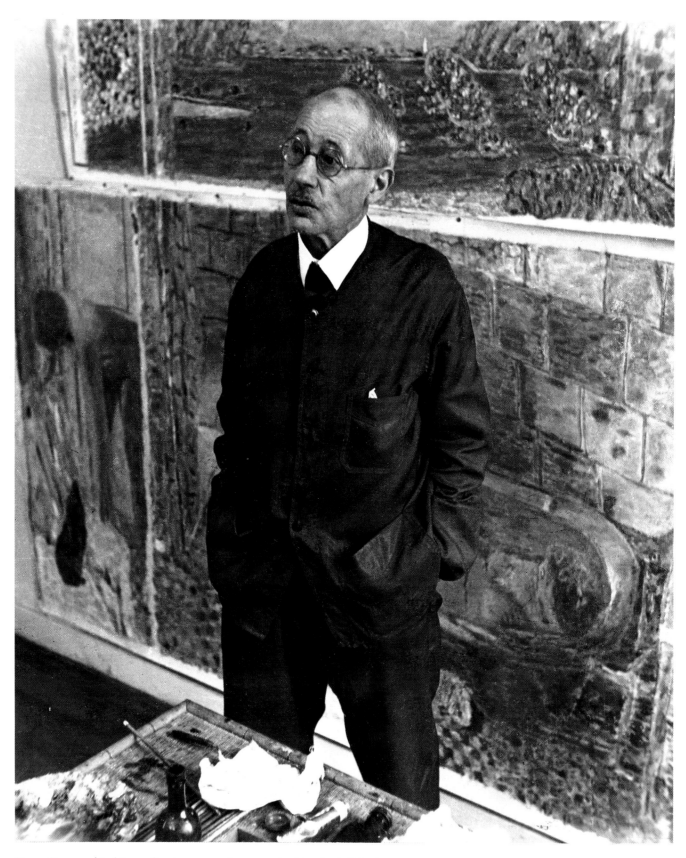

Pierre Bonnard in his studio, in 1941, photographed by André Ostier.

The Côte d'Azur

Pages from Bonnard's diary, 1934.

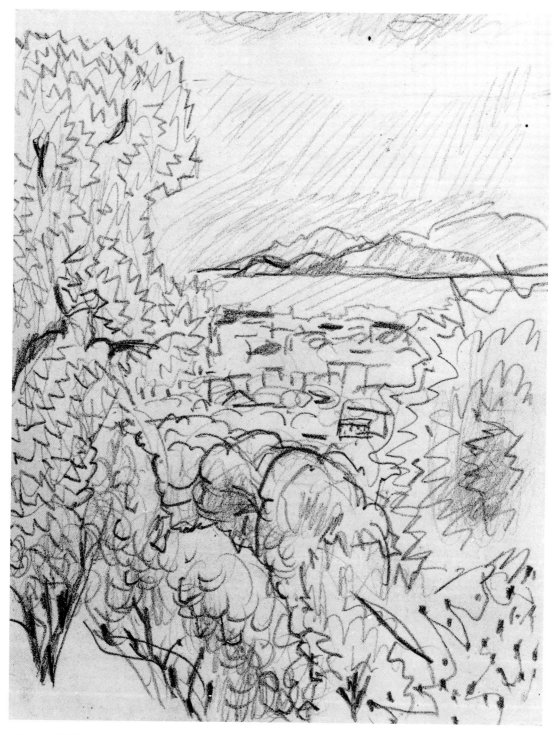

L'Esterel (*The Esterel*), *c.* 1923. (16 x 12.5 cm). Pencil.

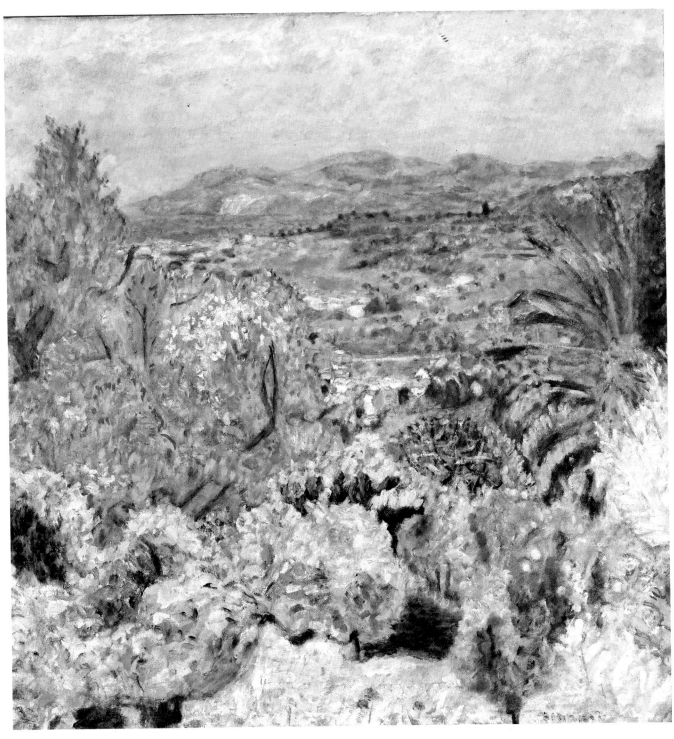

La Côte d'Azur (The Côte d'Azur), *c.* 1923. (79 x 76 cm). The Phillips Collection, Washington, D.C.

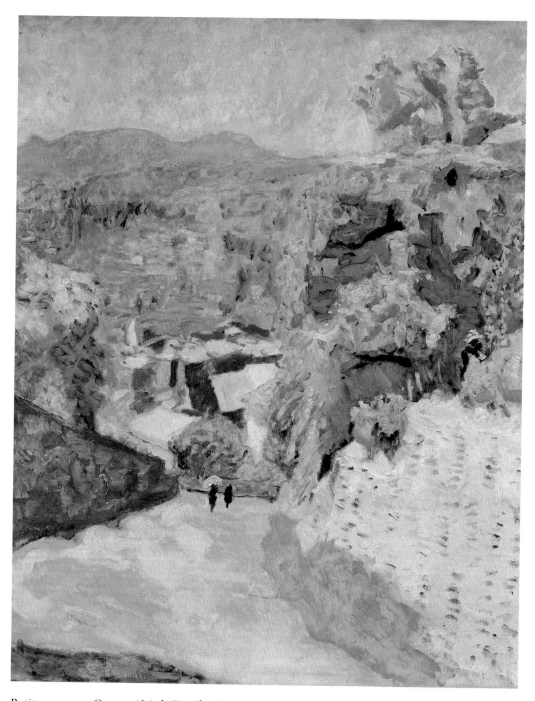

Petite route au Cannet (*Little Road in Le Cannet*), 1924. (78 x 63 cm). Private Collection.

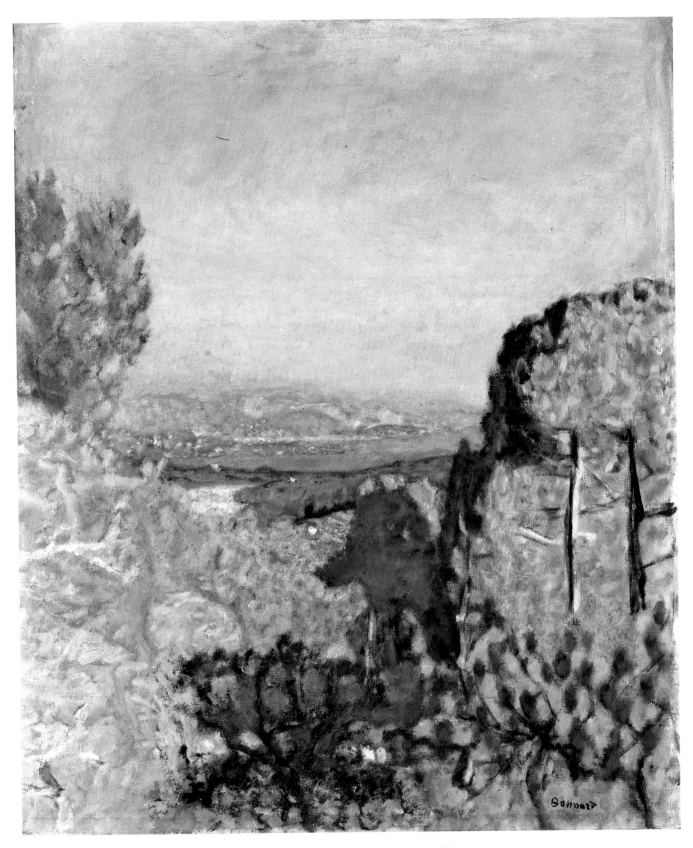

La forêt de pins (*The Pine Forest*), 1922. (56 x 47 cm). Private Collection, USA.

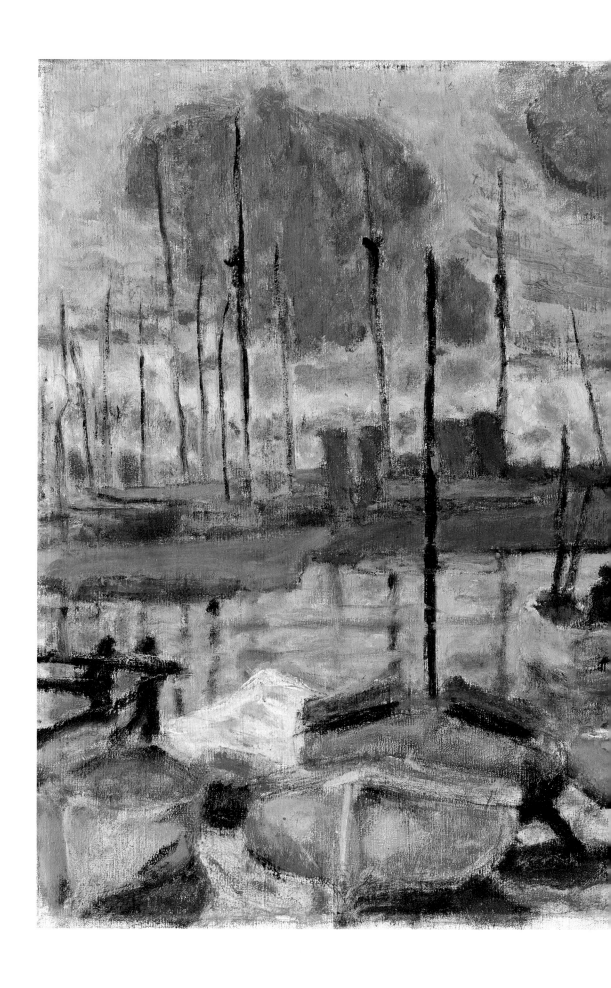

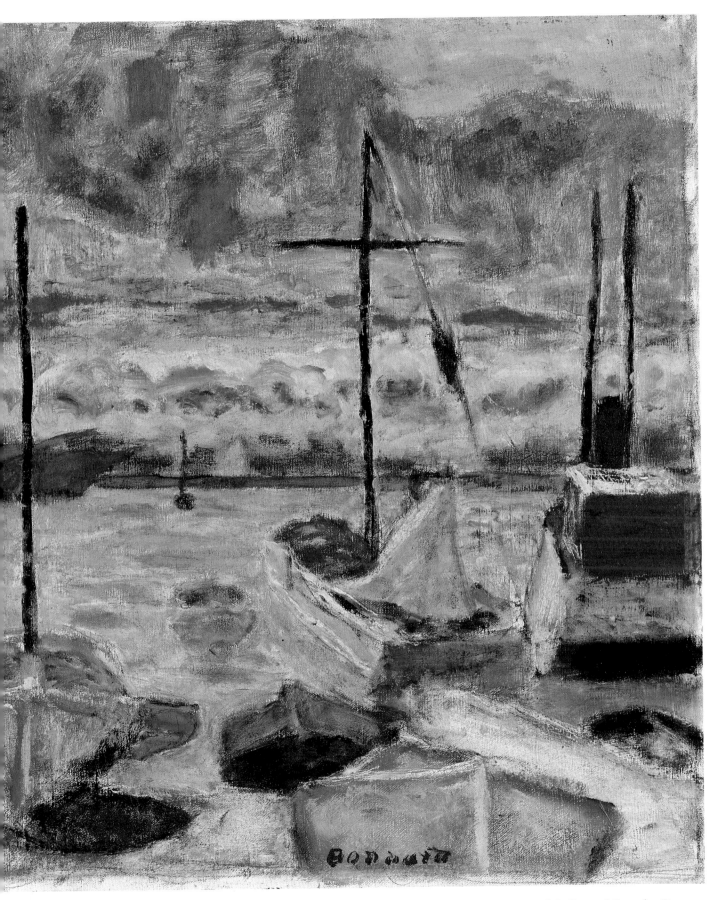

Le port orageux. Cannes (*The Stormy Harbour. Cannes*), 1927. (42 x 72 cm). The National Gallery of Canada, Ottawa.

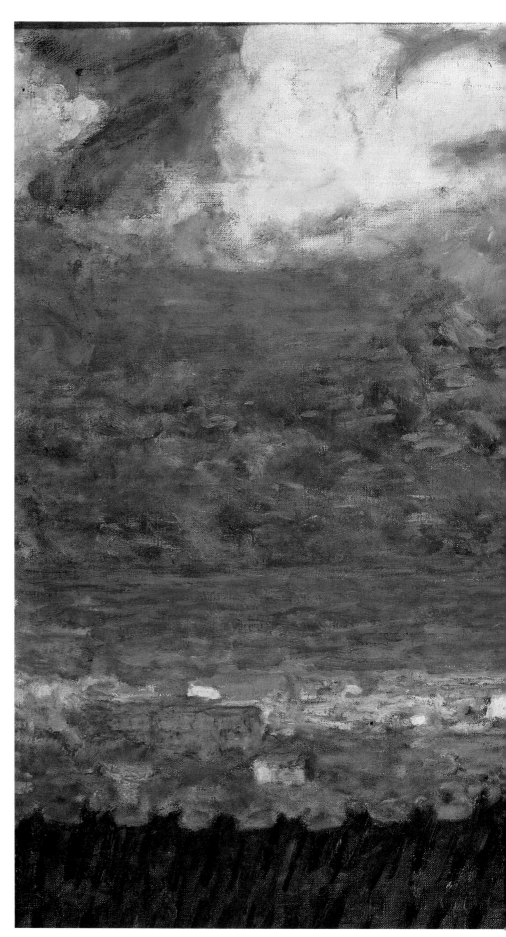

Ciel d'orage sur Cannes
(*Stormy Sky over Cannes*), 1945.
(51 x 75 cm).
Private Collection, Paris.

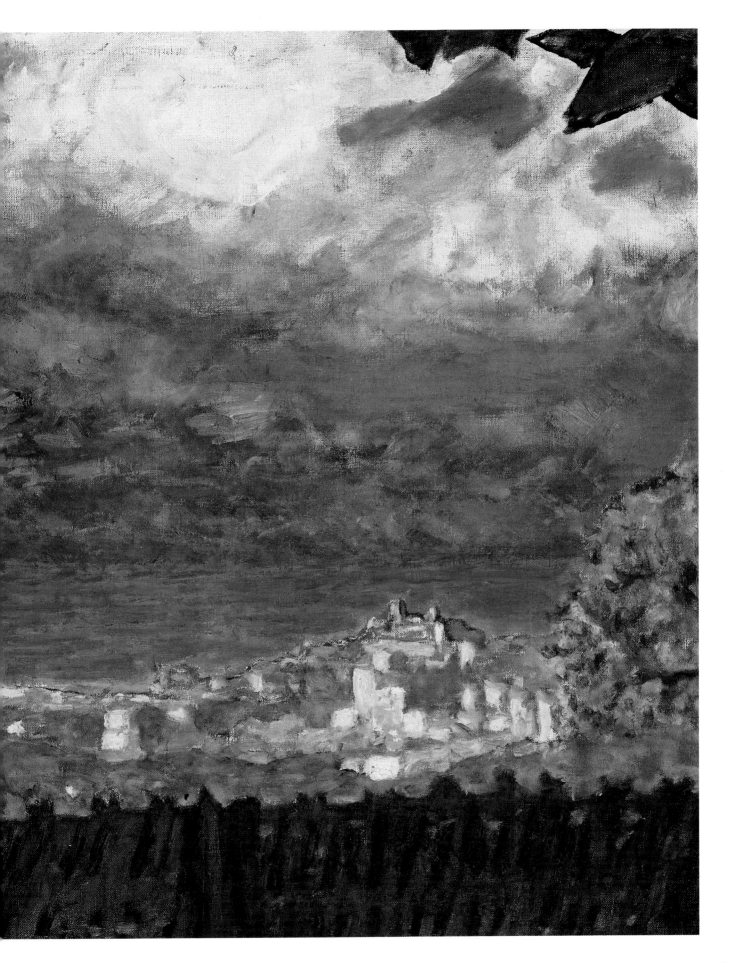

La descente au Cannet (*The Descent to Le Cannet*), 1940. (65 x 72 cm).
The Metropolitan Museum of Art, New York.
(The house is the painter's.)

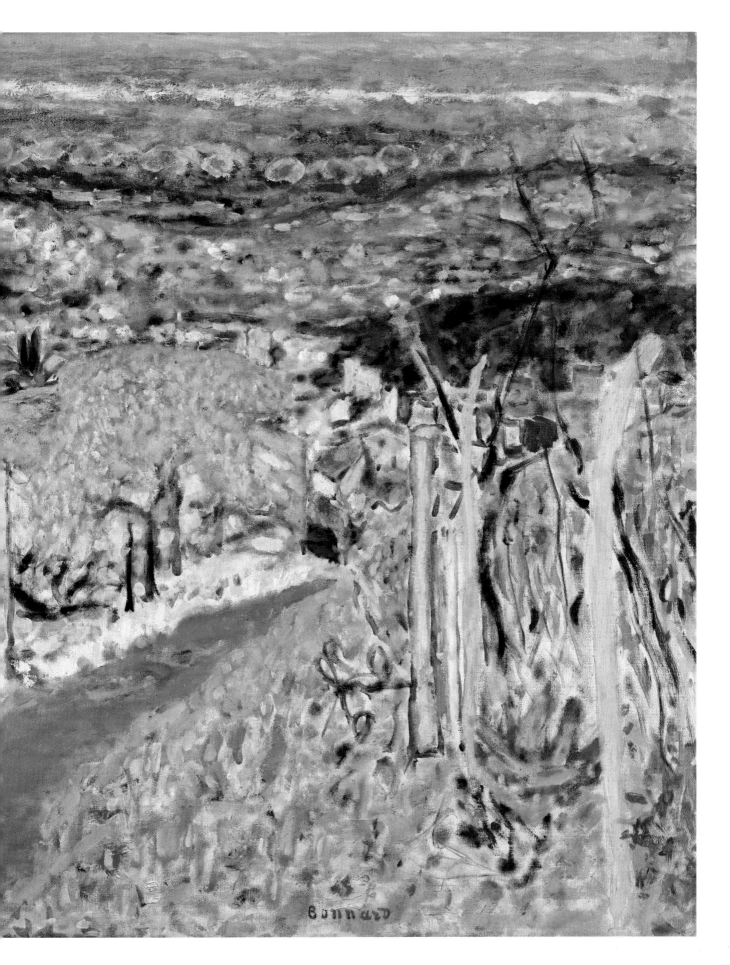

La maison du peintre (*The Painter's House*), *c.* 1939. Pencil.

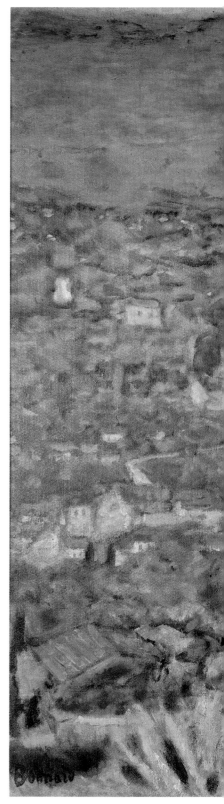

Vue panoramique du Cannet (*Panoramic View of Le Cannet*), 1941.
(80 x 104 cm). Private Collection, USA. (The painter's house is on the left,
the former Villa 'La Tany' on the right.)

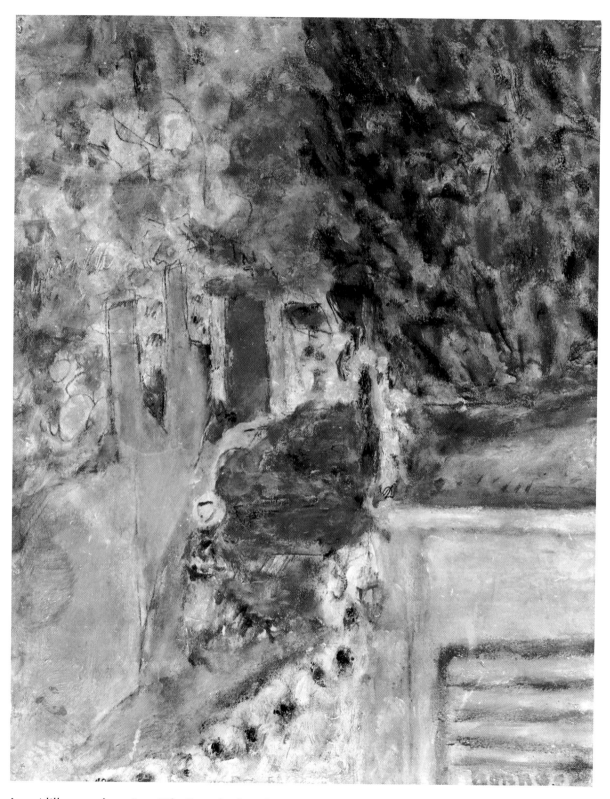

Le raidillon vers la maison (*The Steep Path to the House*), 1946. (41 x 53 cm). Private Collection.

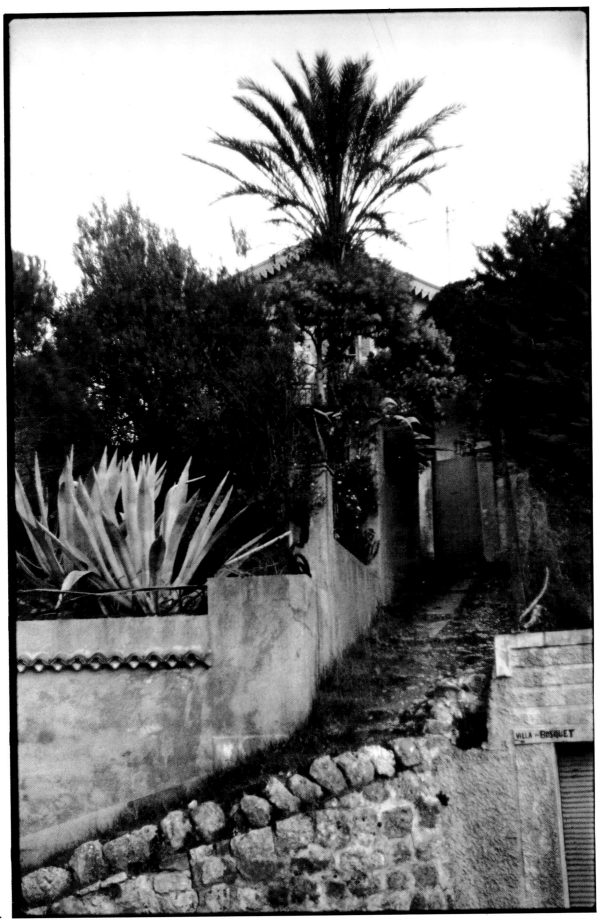

H.C.B.

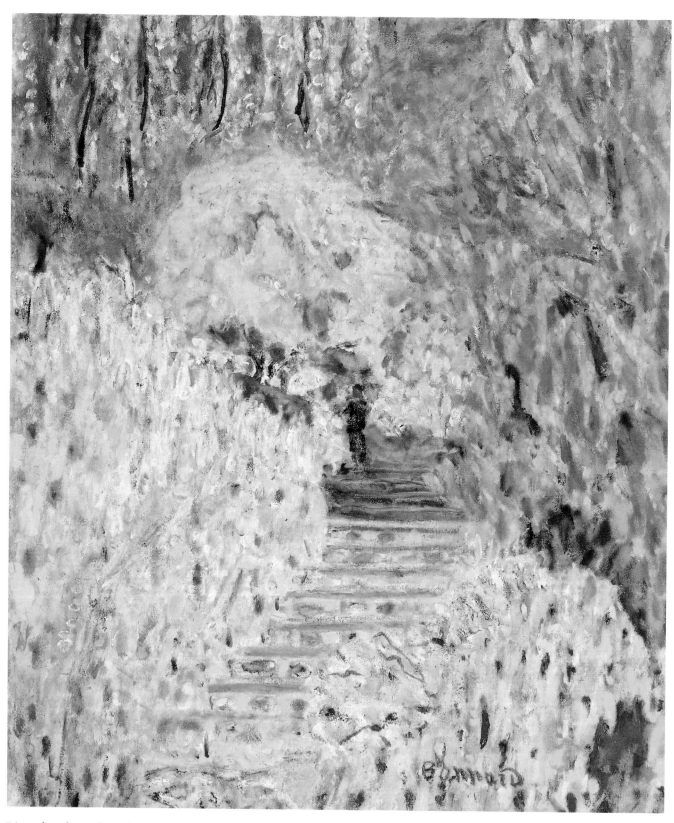

L'escalier du jardin (*The Garden Steps*), *c.* 1940. Private Collection.

The Garden

Drawing. (13 x 14 cm). Pencil.

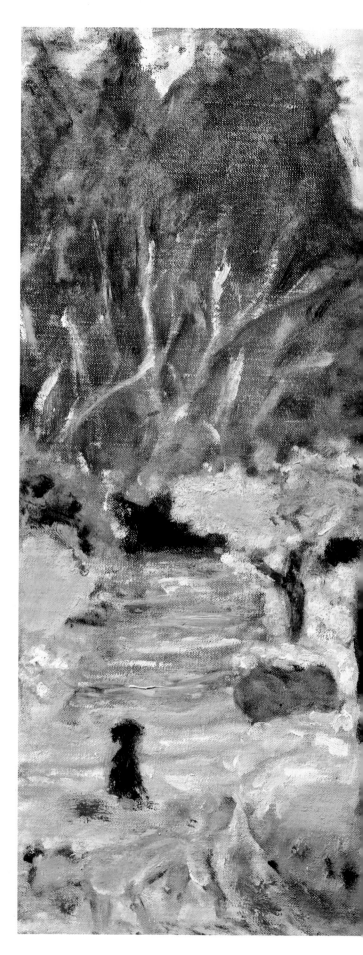

Le jardin au basset (*The Garden with a Dachshund*), *c.* 1927. (44 x 53 cm). Private Collection, USA.

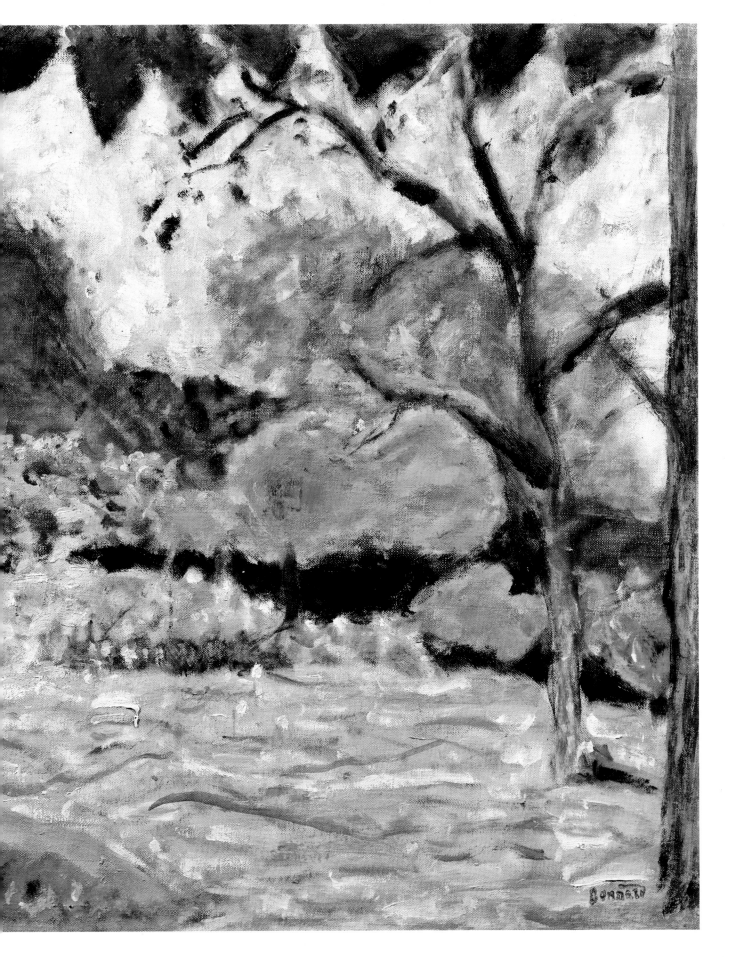

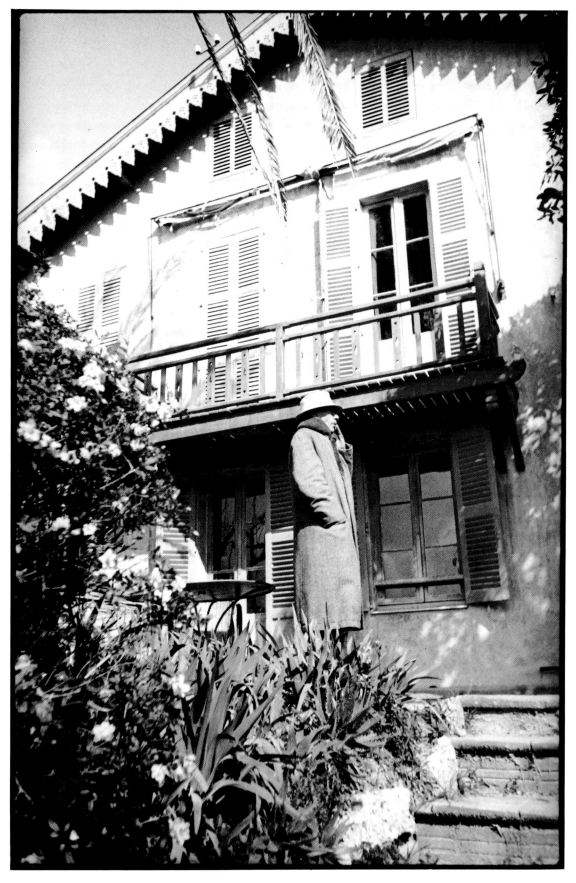

H.C.B.

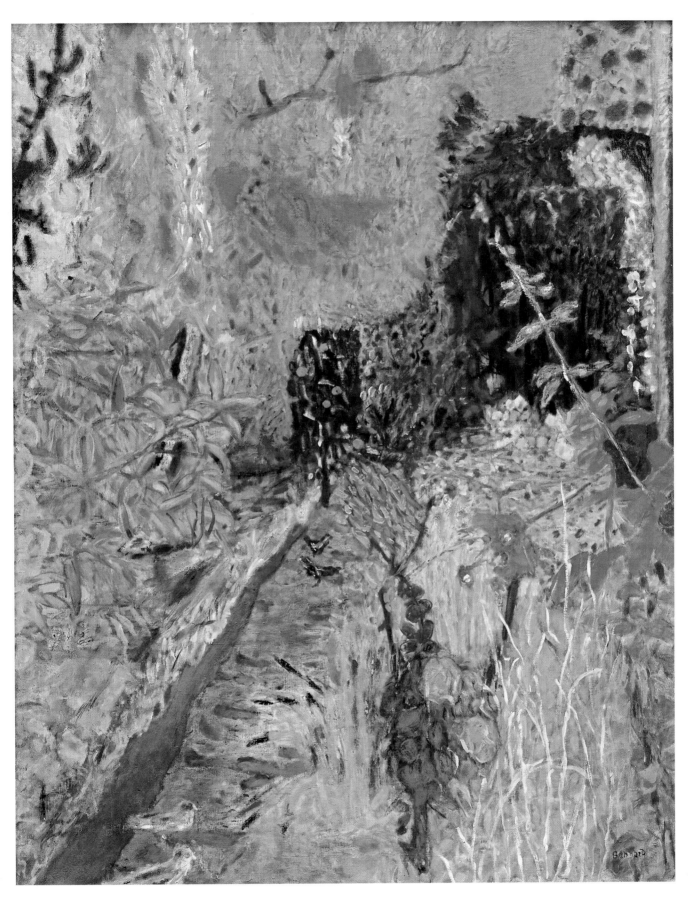

Le jardin (*The Garden*), *c.* 1937. (127 x 100 cm). Musée du Petit-Palais, Paris.

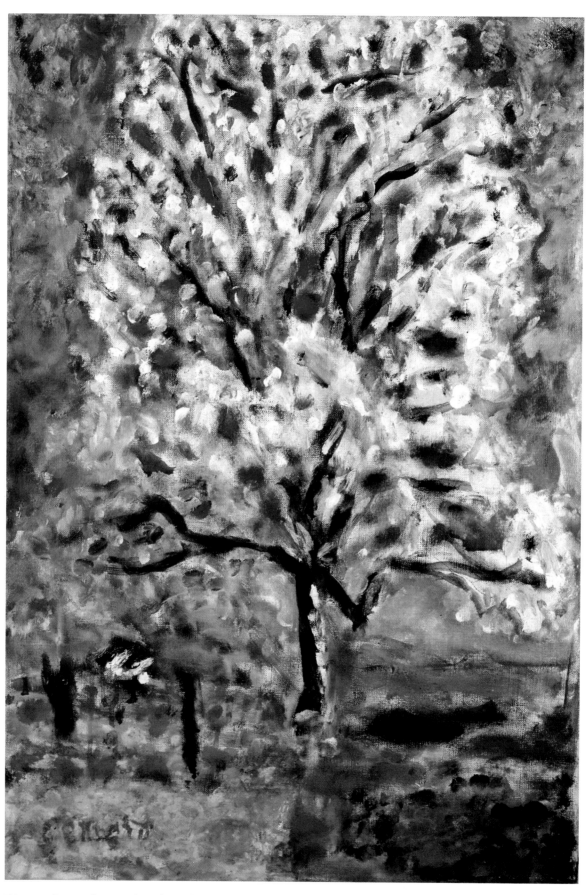

L'amandier en fleurs (*The Almond Tree in Blossom*), 1945. (55 x 37.5 cm).
Musée National d'Art Moderne, Paris. (Finished in 1947 – Bonnard's last painting.)

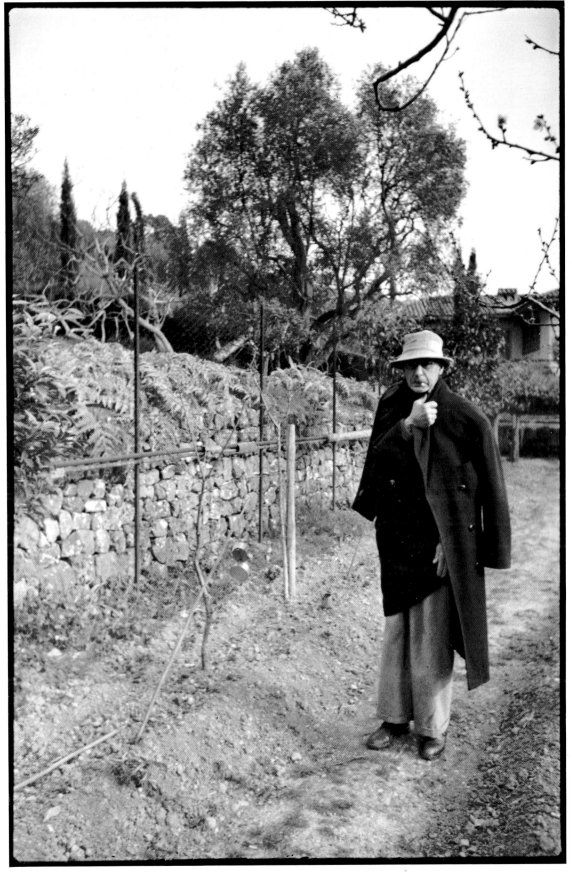

H.C.B.

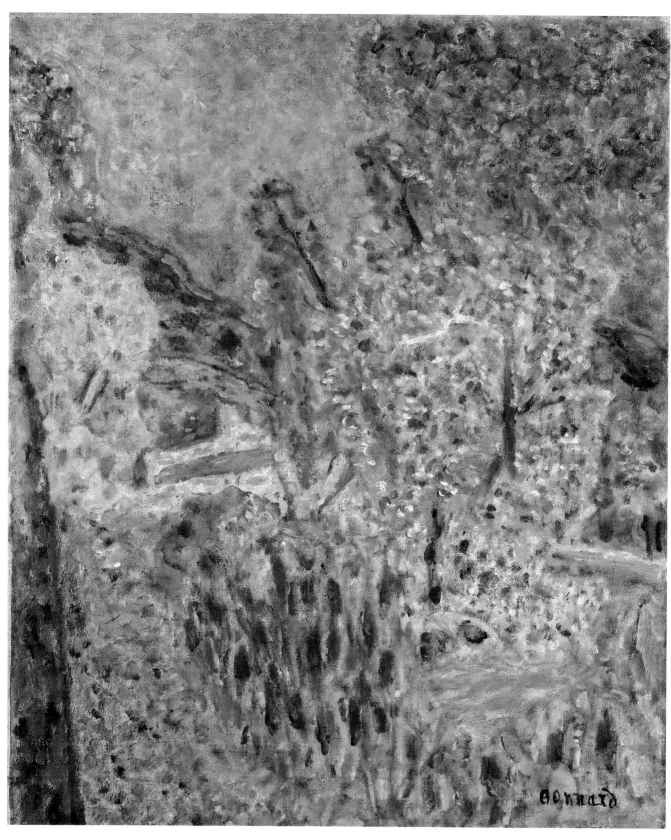

Le jardin (*The Garden*), 1943. (63 x 55 cm). Private Collection, Paris.

The Dining Room

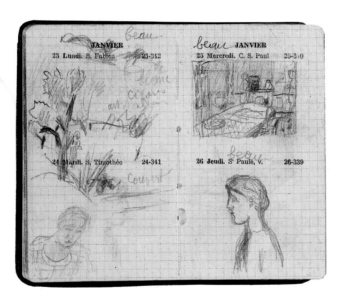

Pages from Bonnard's diary, 1933.

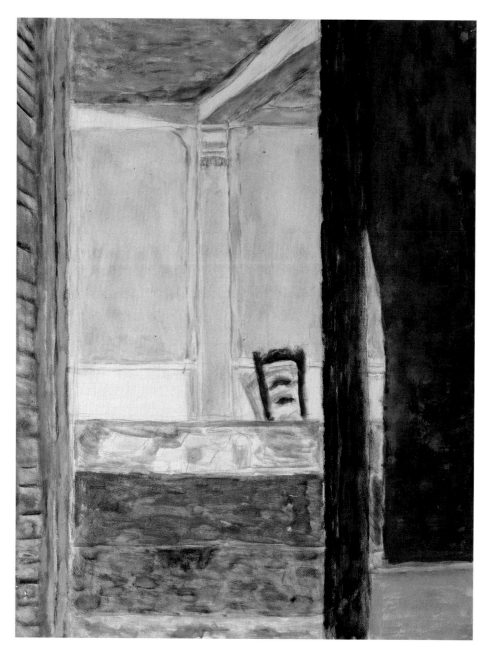

Vue sur la salle à manger (*View of the Dining Room*), 1945.
(65 x 50 cm). Gouache. Private Collection.

Marthe dans la salle à manger (*Marthe in the Dining Room*), 1933.
(111 x 69 cm). Musée des Beaux-Arts, Lyons.

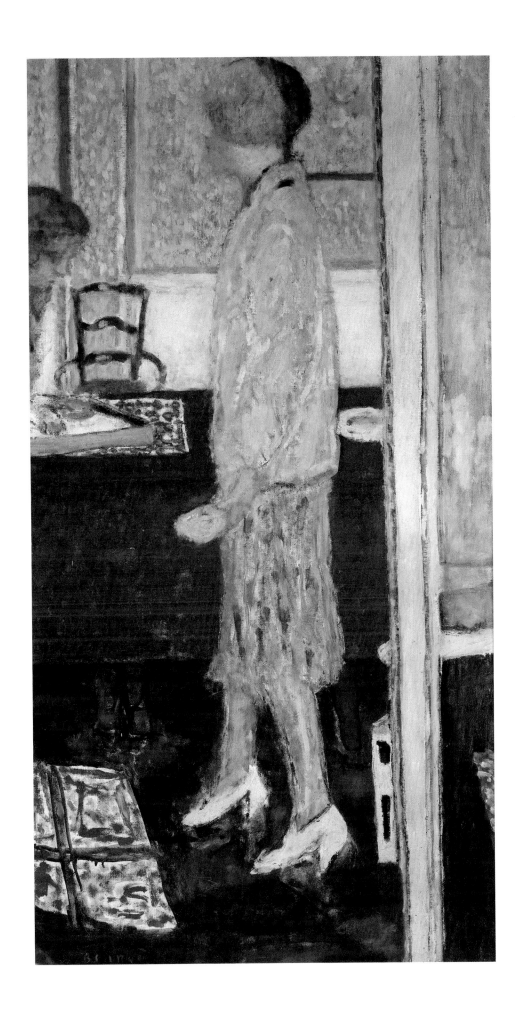

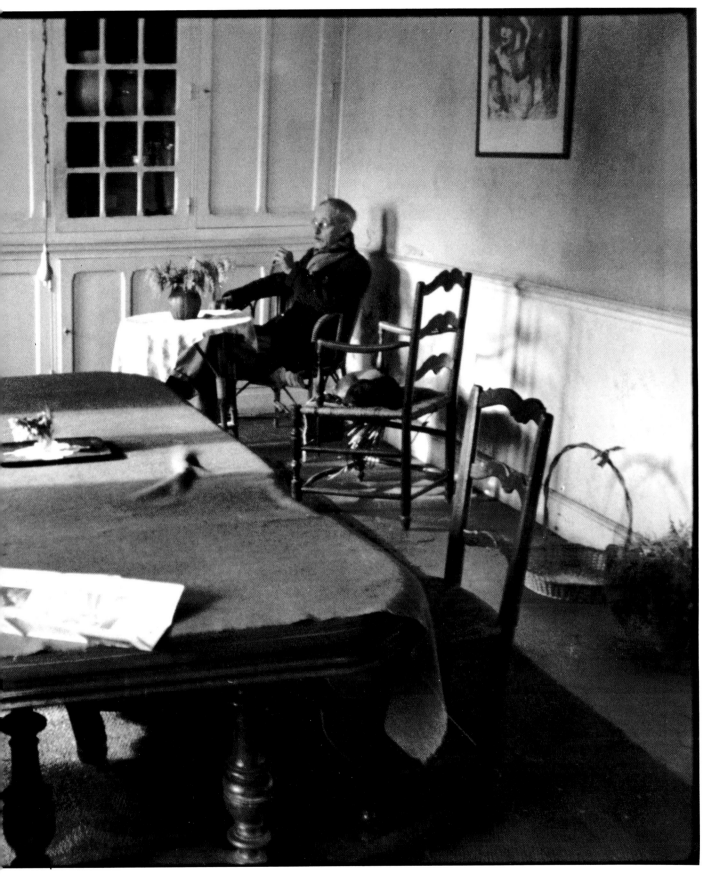

H.C.B.

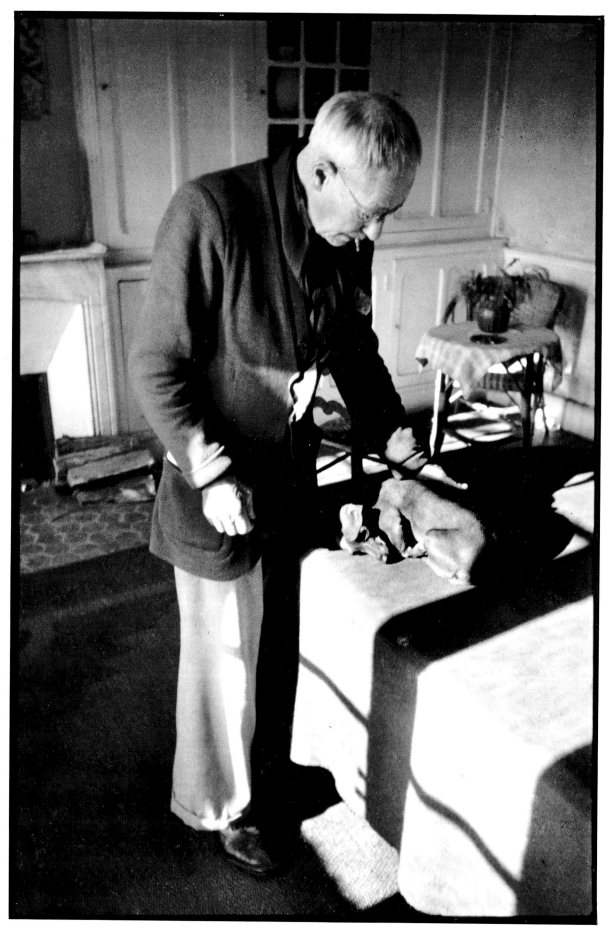

H.C.B.

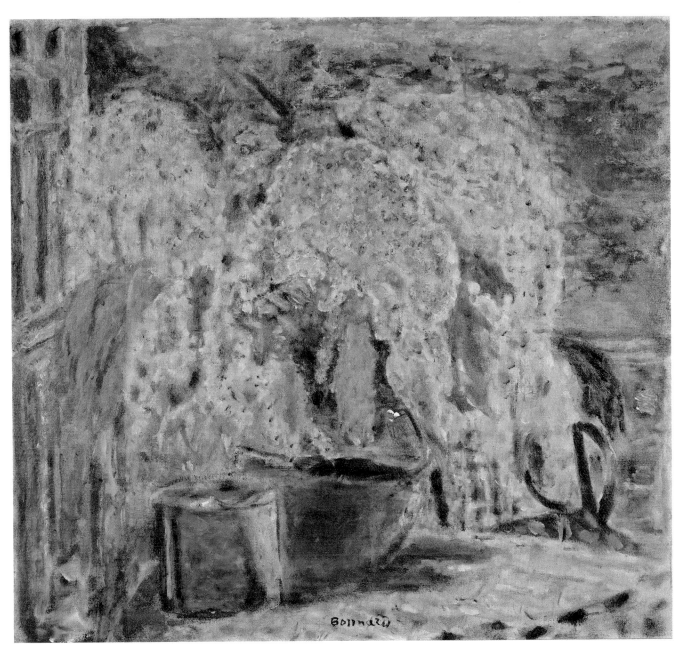

Bouquet de mimosas (*Bunch of Mimosa*), *c.* 1945. (62 x 68 cm). Private Collection, France.

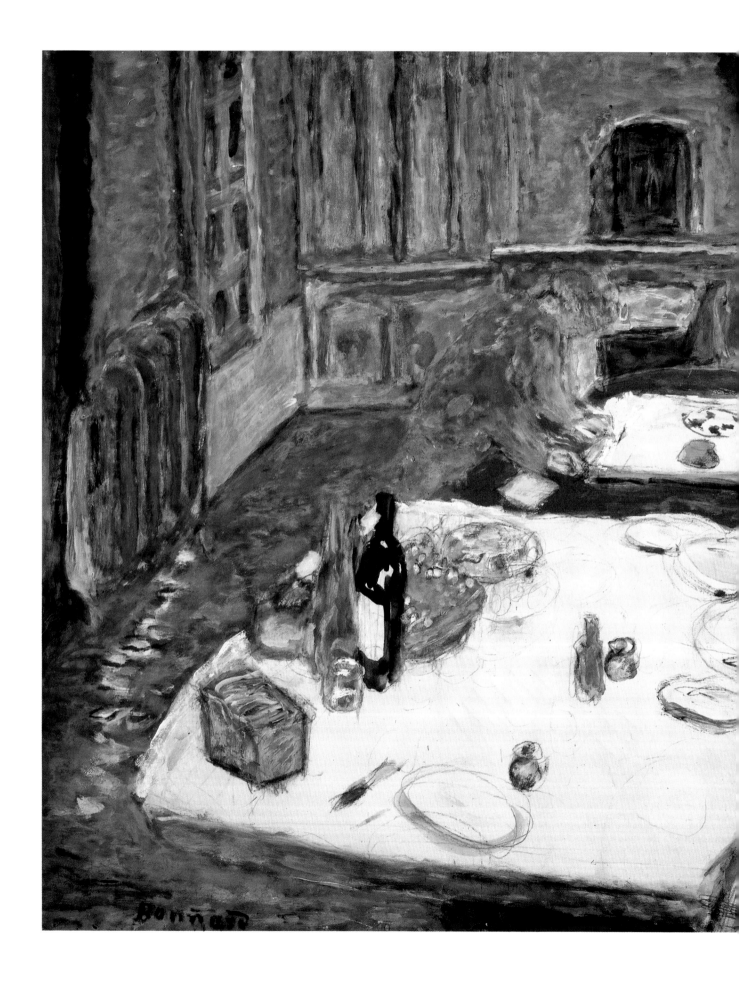

Le poste de T.S.F. (The Wireless Set), c. 1940. Pencil.

La préparation du dîner (Preparing Dinner), 1940.
(39.5 x 64.8 cm). Gouache. The Art Institute of Chicago.

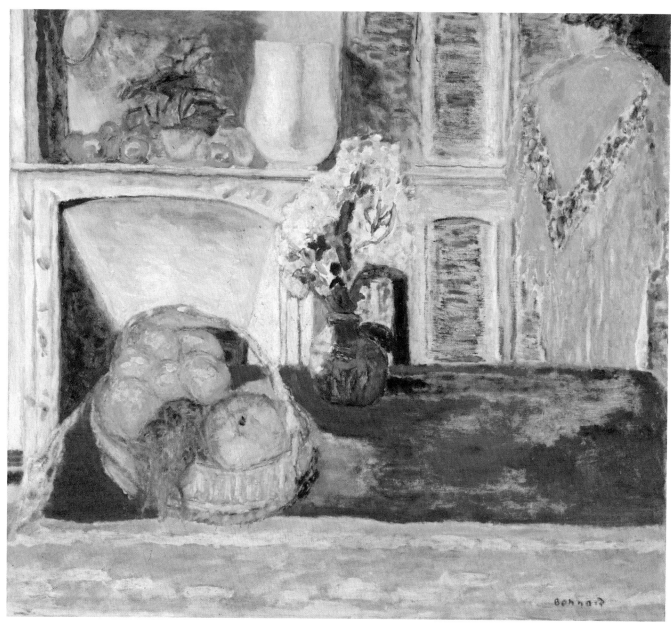

Coin de salle à manger (*Corner of the Dining Room*), 1932. (81 x 90 cm). Musée National d'Art Moderne, Paris.

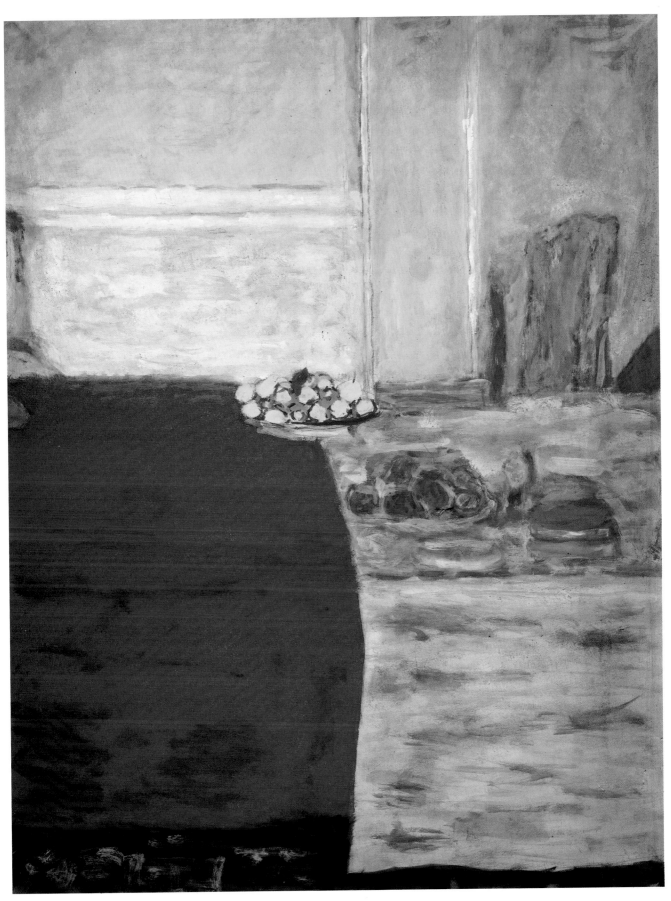

Fruits sur le tapis rouge (*Fruit on the Red Tablecloth*), *c.* 1943. (64 x 48 cm). Gouache. Private Collection.

Coupe et corbeille de fruits (*Bowl and Basket of Fruit*), 1944.
(42 x 52 cm). Private Collection.

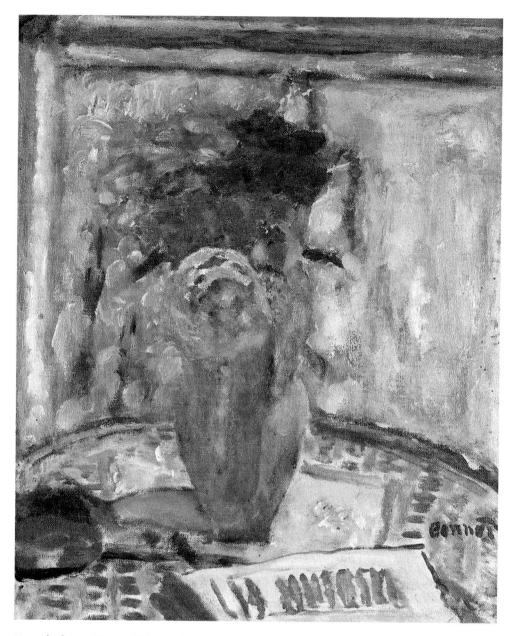

Vase de fleurs (*Vase of Flowers*), 1945. (39 x 32 cm). Private Collection, France.

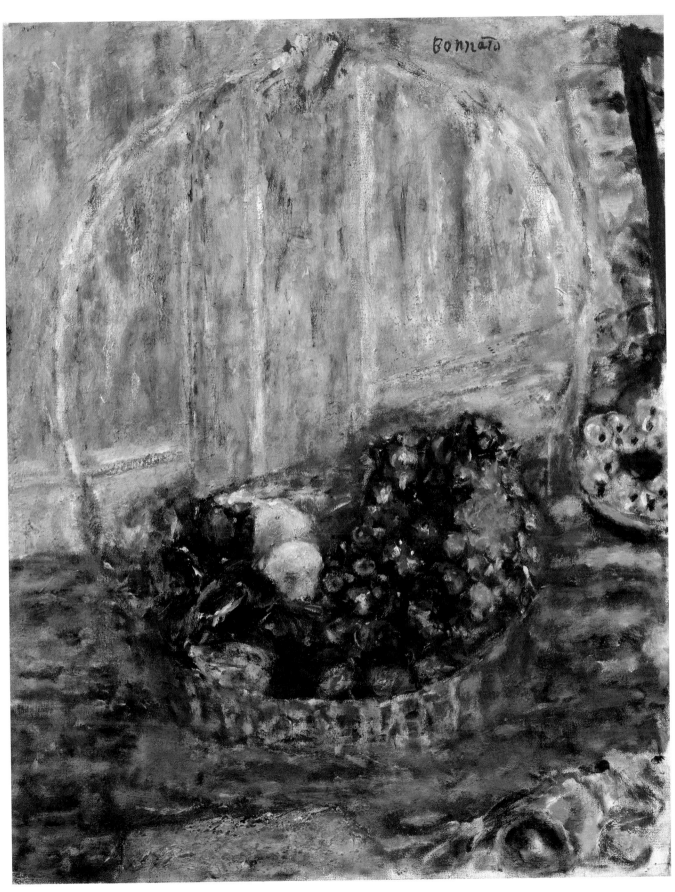

Corbeille de fruits (Basket of Fruit), *c.* 1946. (86.5 x 71 cm). The Reader's Digest Association, USA.

Drawing. (16 x 12.5 cm). Pencil.

Drawing. (16 x 12.5 cm). Pencil.

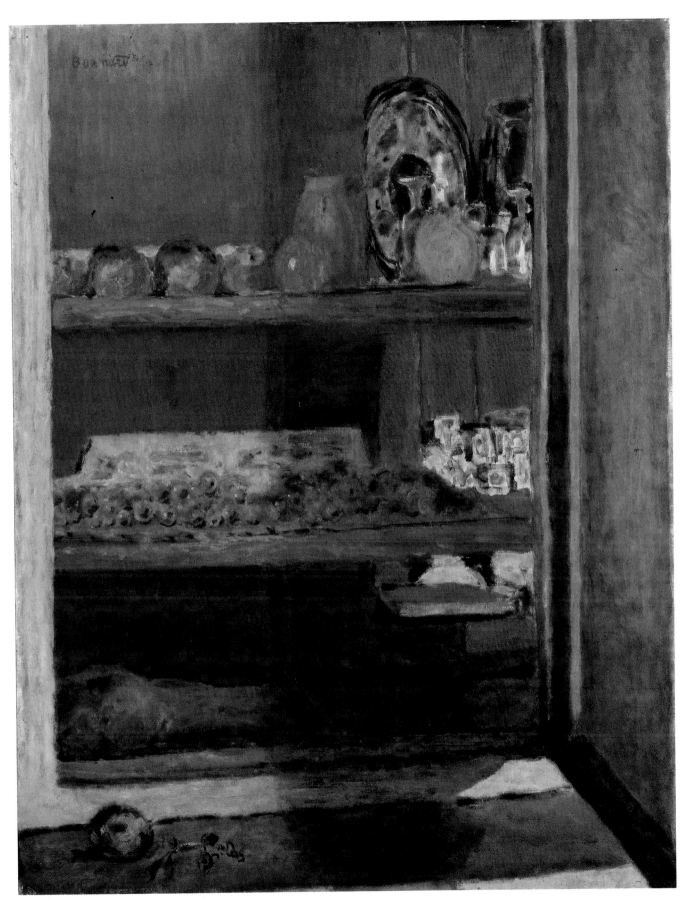

Le placard rouge (*The Red Cupboard*), 1939. (80 x 60 cm). Private Collection.

Corbeille de fruits dans le placard rouge (*Basket of Fruit in the Red Cupboard*), 1945.
(45 x 71 cm). Private Collection, Switzerland.

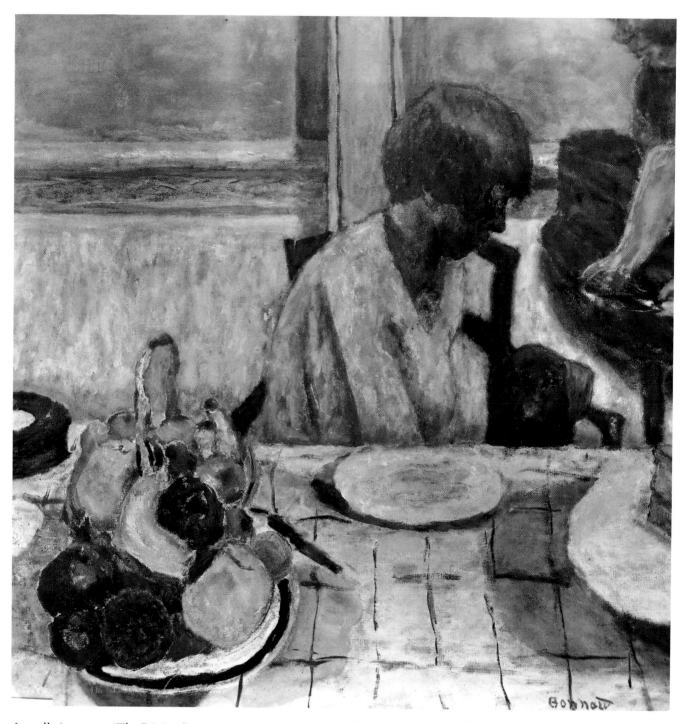

La salle à manger (*The Dining Room*), *c.* 1927. (76 x 75 cm). Private Collection, USA.

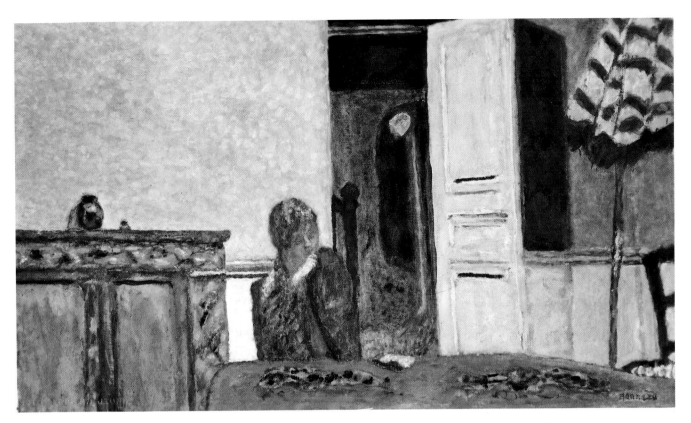

La salle à manger au parasol (*The Dining Room with a Parasol*), 1932. (85 x 50 cm). Private Collection.

The pictures of Marthe in *La salle à manger au parasol* (*The Dining Room with a Parasol*), and Marthe and the dachshund in *La salle à manger* (*The Dining Room*) deserve to be shown in all their rich colours. However, being in private collections, the paintings have changed ownership and even continents over the decades, and despite our diligent research it has sometimes been impossible to trace them. Perhaps this book will be of assistance.

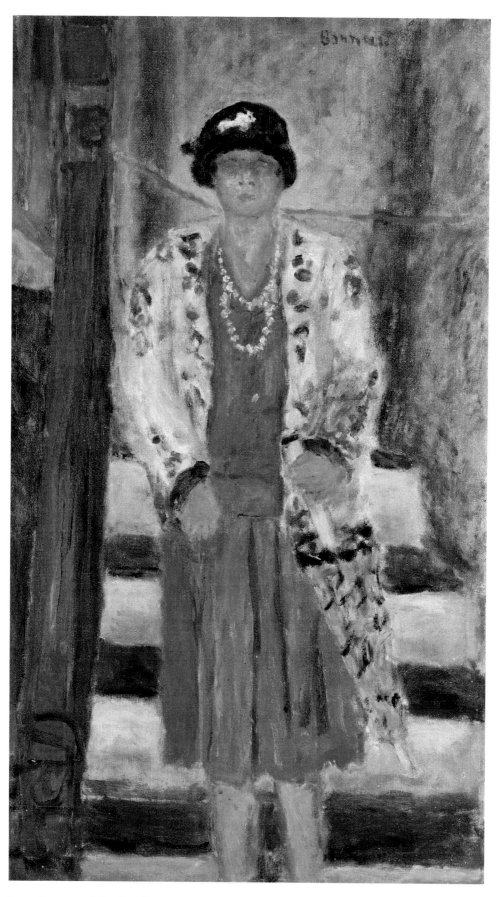

La robe rouge (*The Red Dress*), 1927. (72 x 42 cm). Private Collection.

The Small Sitting Room

Drawing, 1927. (12.5 x 18 cm).
Pencil and red crayon.

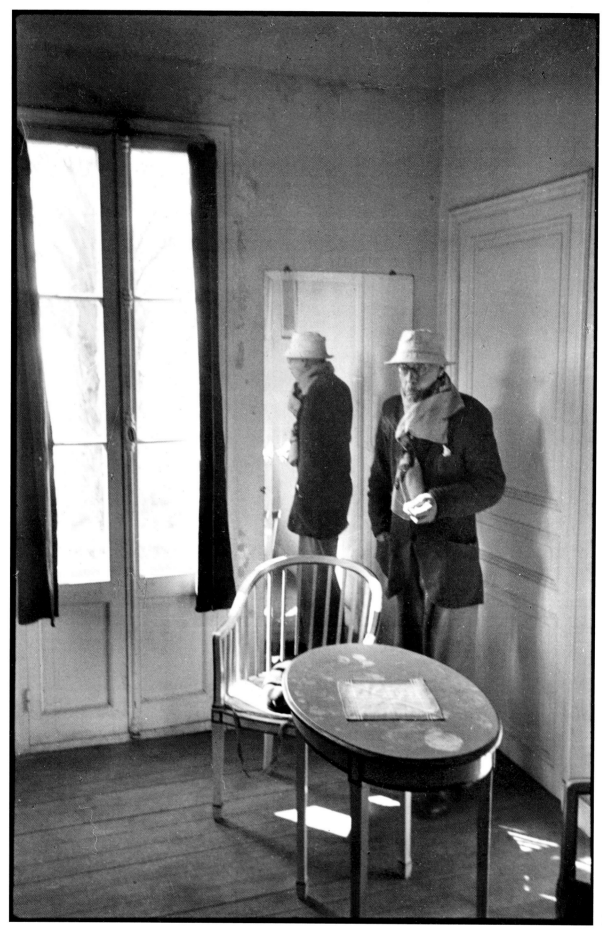

H.C.B.

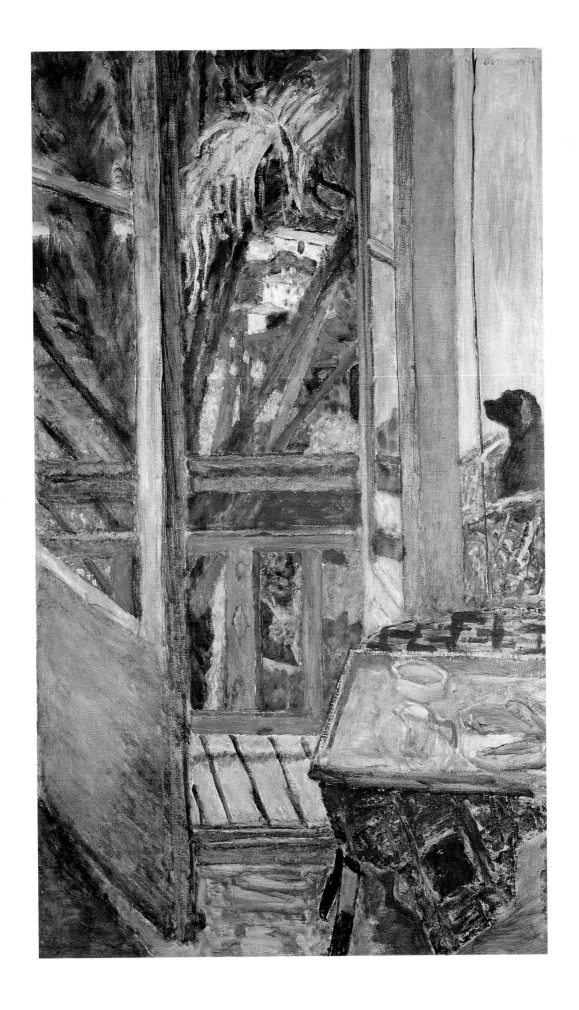

Preceding page: *La porte-fenêtre avec chien*
(*The French Windows with Dog*), 1927.
(105 x 63 cm). Private Collection, USA.

La porte fenêtre ou matinée au Cannet
(*The French Windows or Morning
at Le Cannet*), 1929.
(86 x 112 cm). Private Collection, France.
 The painter appears in the mirror.)

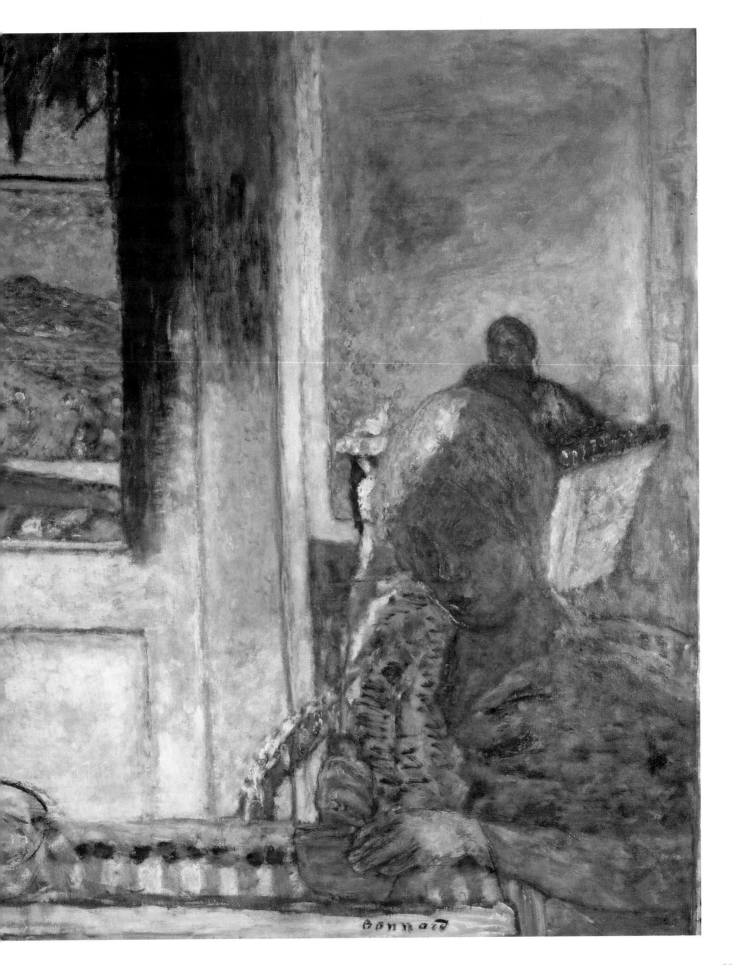

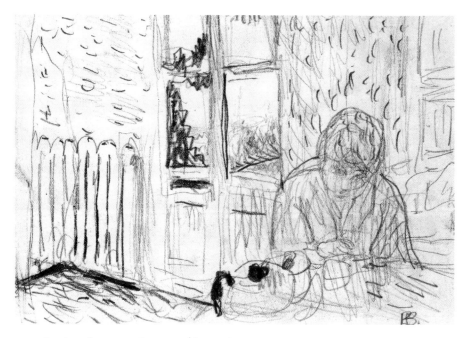

Marthe dans le petit salon (Marthe in the Small Sitting Room), c. 1938. Pencil.

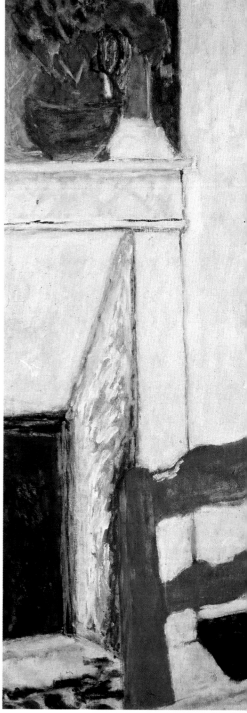

L'intérieur blanc (The White Interior), 1929. (109 x 162 cm).
Musée de Grenoble.

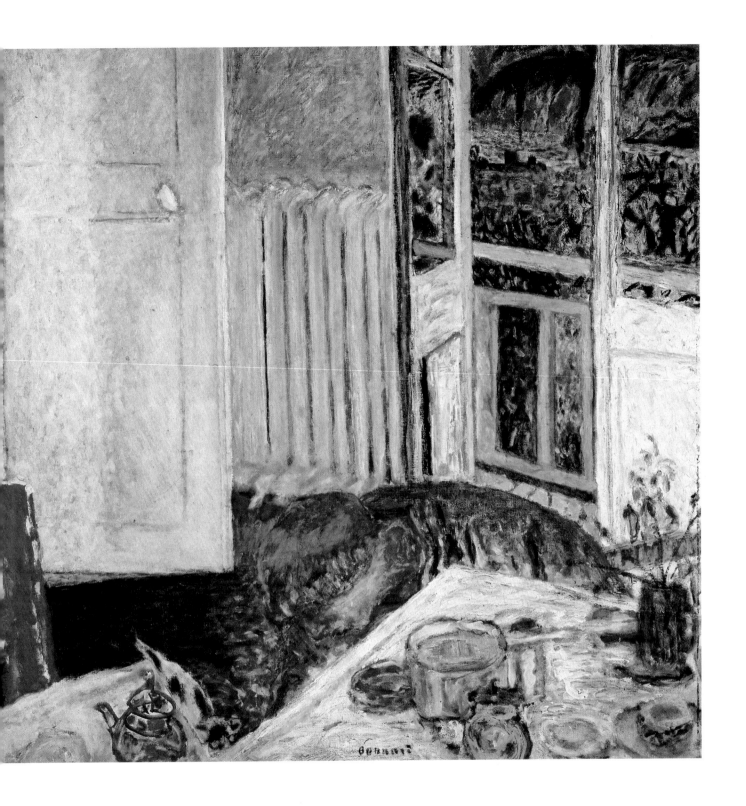

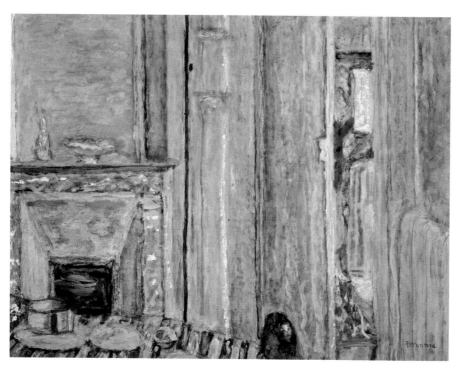

L'intérieur gris (*The Grey Interior*), *c.* 1942. Gouache. Private Collection, USA.

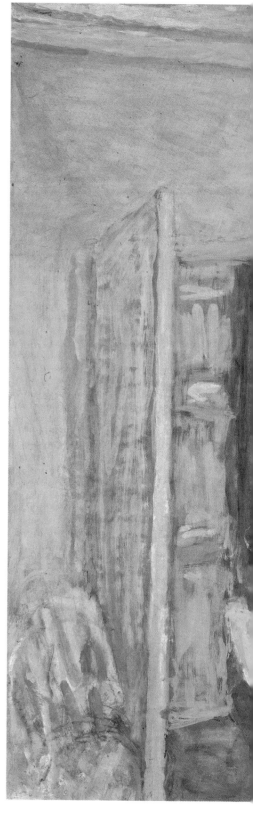

L'intérieur jaune (*The Yellow Interior*), *c.* 1942. Gouache.
Private Collection, Paris.
(The small sitting room, opening on to the bathroom on the right.)

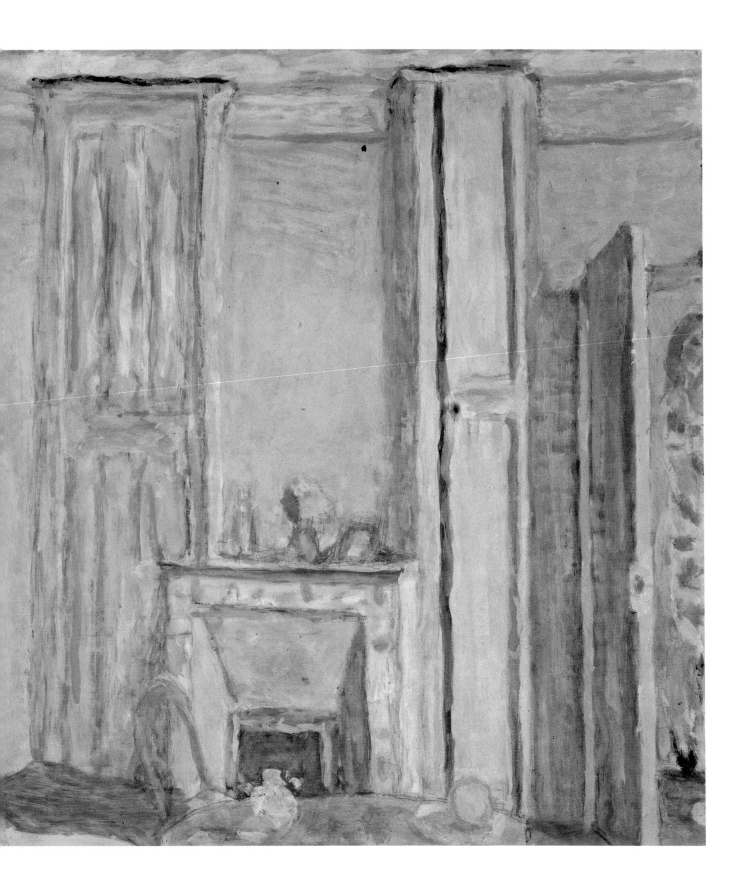

Drawing. (16 x 12.5 cm). Pencil.

Vase de fleurs sur la cheminée (*Vase of Flowers on the Mantelpiece*), 1930.
(98 x 56 cm). Private Collection, Switzerland.

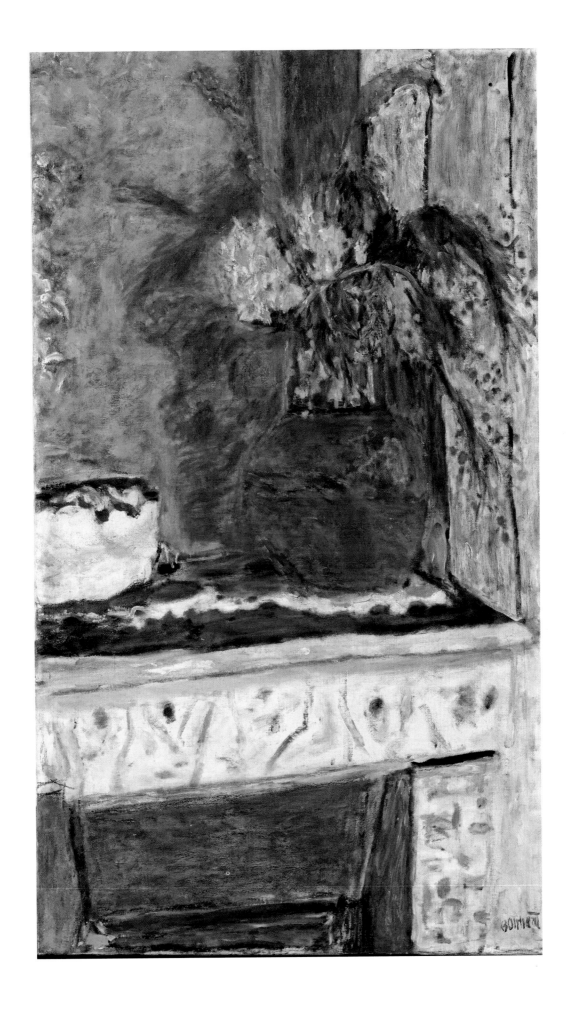

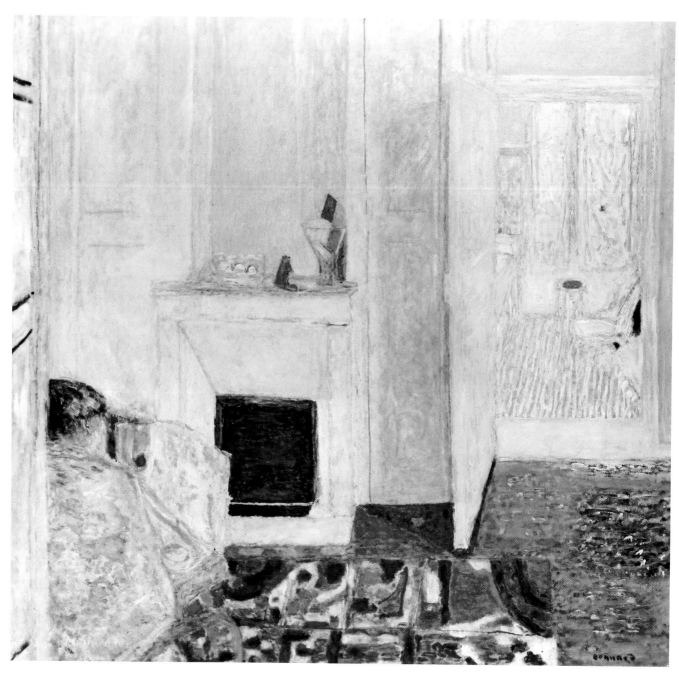

Le petit salon et la salle de bains (*The Small Sitting Room and Bathroom*), 1932.

The Bathroom

Pages from Bonnard's diary, 1937.

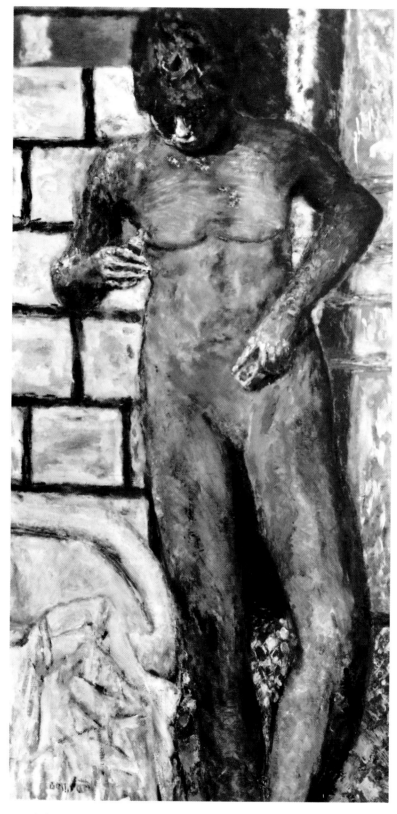

Nu debout (Standing Nude), 1928. (111 x 58 cm). Private Collection.

Le nu gris (The Grey Nude), 1929. (114 x 60 cm). Private Collection.

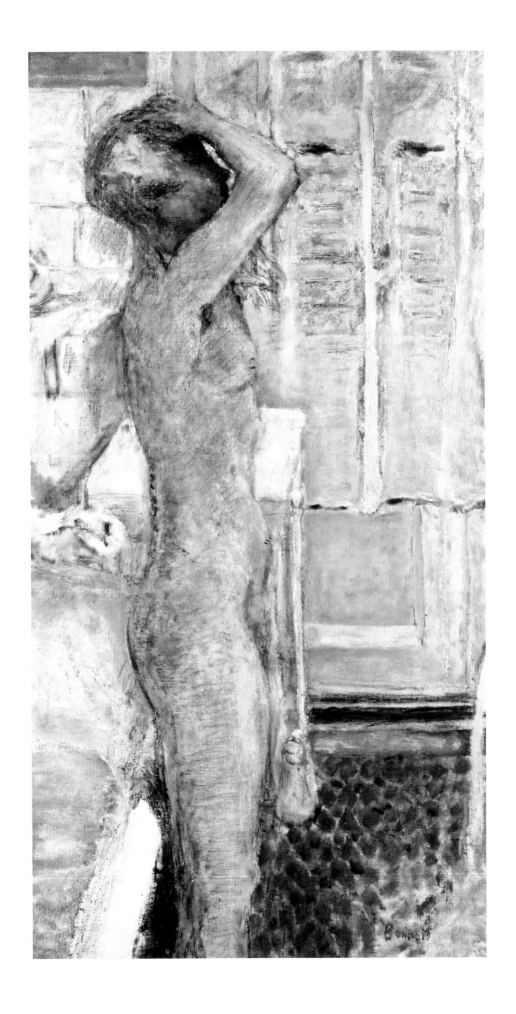

Drawing. (13 x 18.5 cm). Pencil.

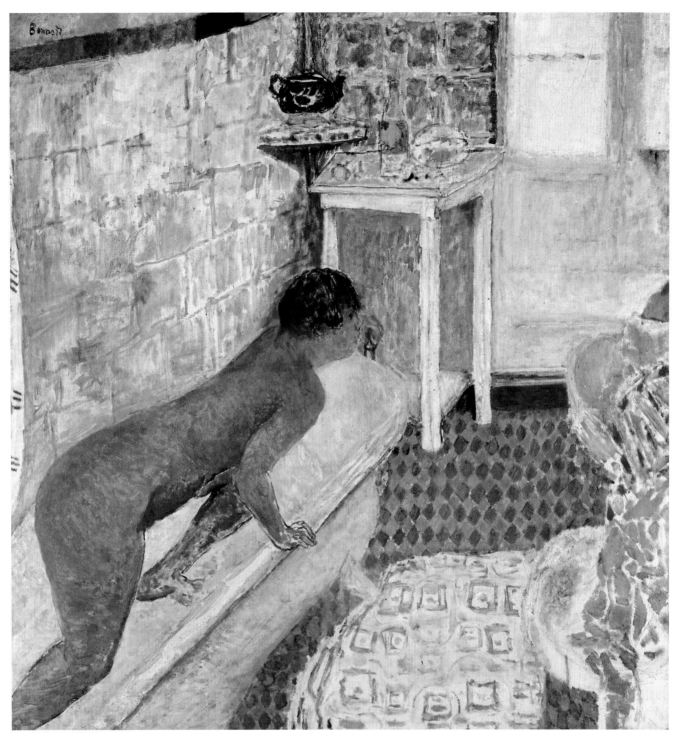

La sortie de la baignoire (*Getting out of the Bath*), *c.* 1930. (129 x 123 cm). Private Collection.

Pages from Bonnard's diary, 1937.

Pages from Bonnard's diary, 1937.

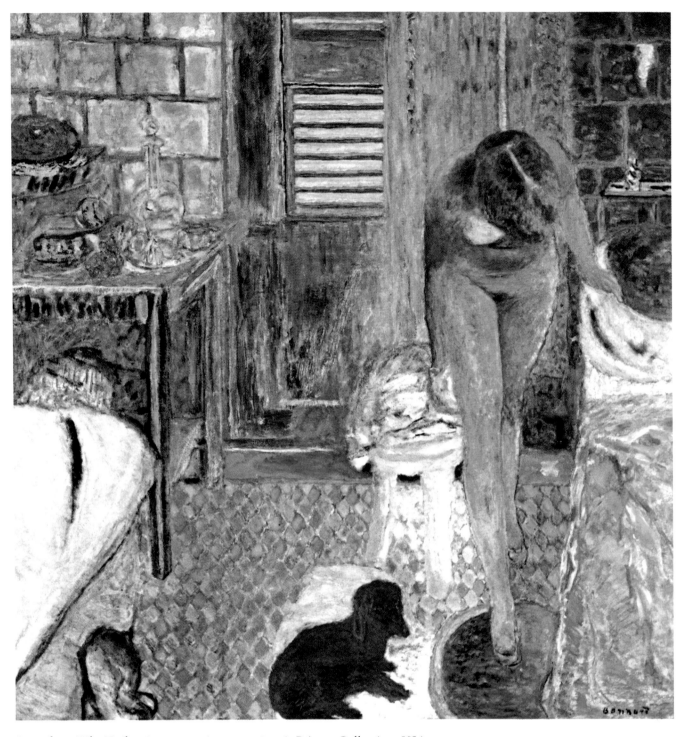

La toilette (*The Toilette*), *c.* 1932. (120 x 118 cm). Private Collection, USA.

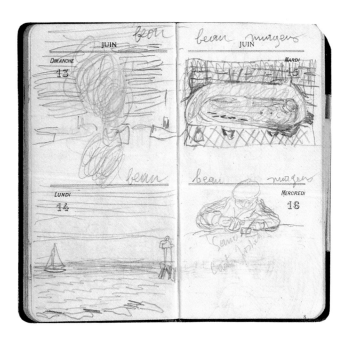

Pages from Bonnard's diary, 1937.

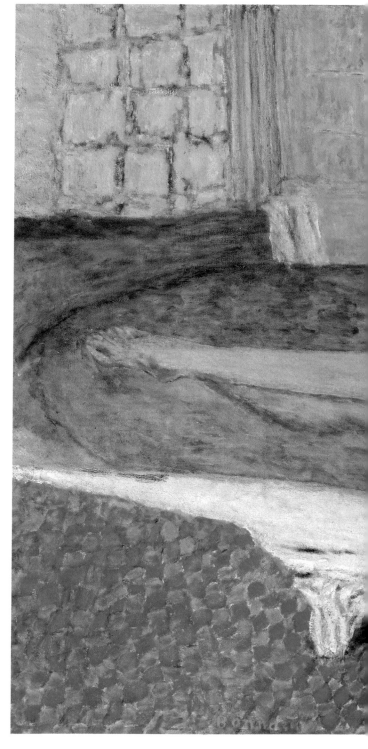

Le nu à la baignoire (*The Nude in the Bath*), 1937.
(93 x 147 cm). Musée du Petit-Palais, Paris.

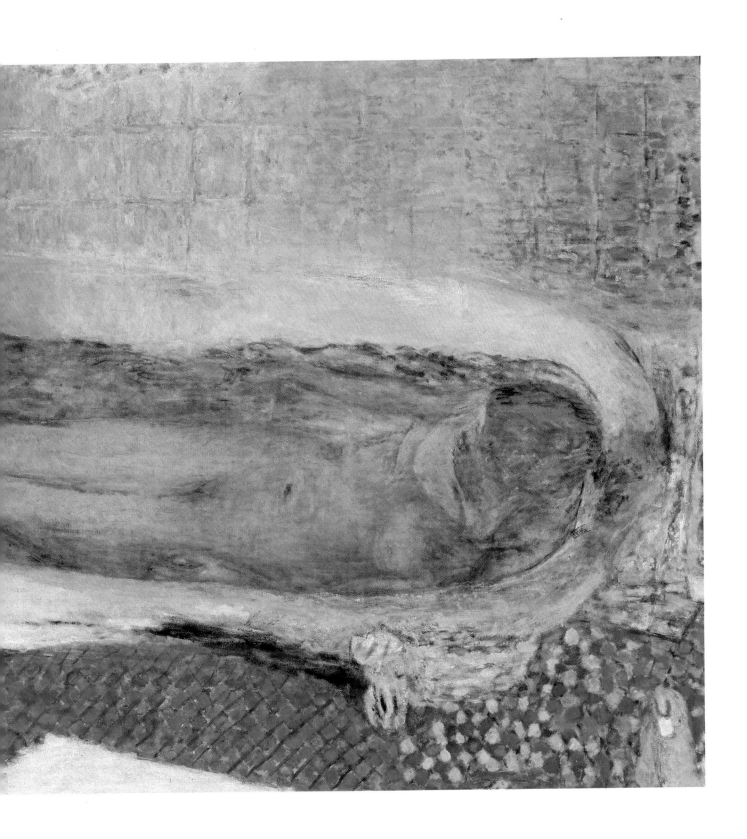

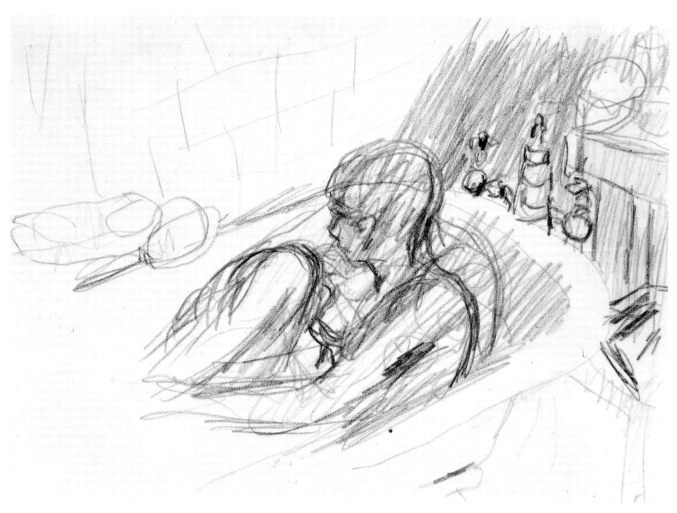

Drawing, 1927. (12.5 x 18 cm). Pencil.

The Painter's Bedroom

Drawing, 1946. Pencil.

Autoportrait (Self-Portrait), 1938. (12.5 x 16 cm). Pencil.

La petite fenêtre (The Little Window), 1946. (58 x 45 cm). Private Collection, Paris.

This *Petite fenêtre (Little Window)* opening on to the garden is, to my knowledge, one of only two paintings by Bonnard of his bedroom. The other – a painting or gouache – appears in a photograph by Henri Cartier-Bresson (see page 107), attached by drawing pins to a piece of cardboard and placed directly on the floor. The painter is in the process of working on it.
In the left-hand part of the painting the wash-basin and mirror appear on one side of the window; on the right is the iron bedstead which, with a cupboard, constituted the entire furnishings of the bedroom.
However, several self-portraits were painted in this modest room. They can be distinguished from those executed in the bathroom because they show the reflection of a cupboard, while glazed tiles are reflected in the bathroom mirror.

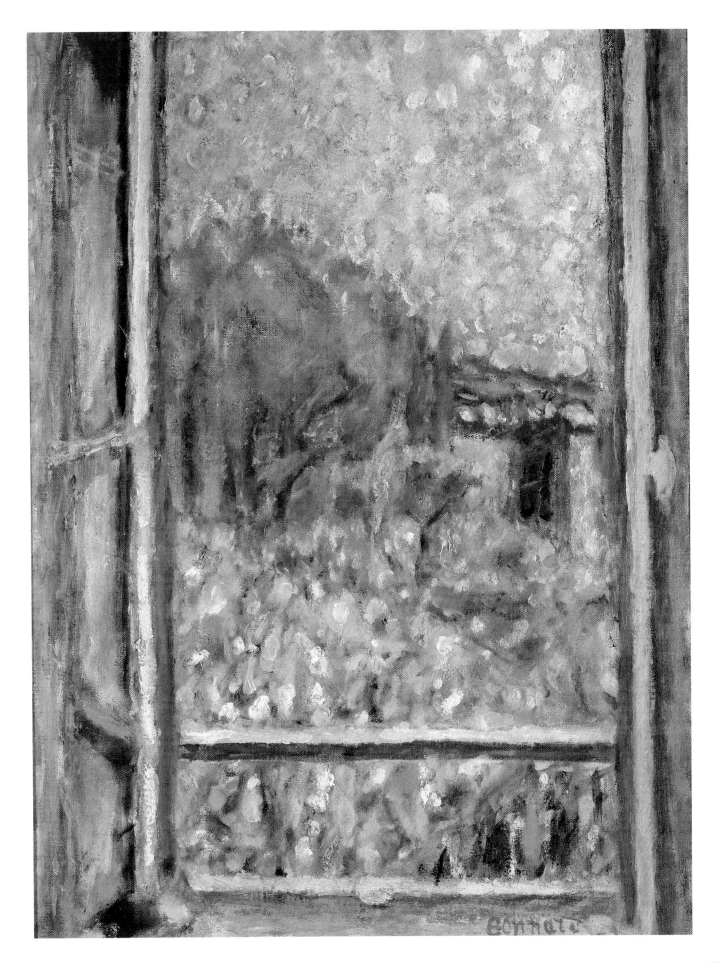

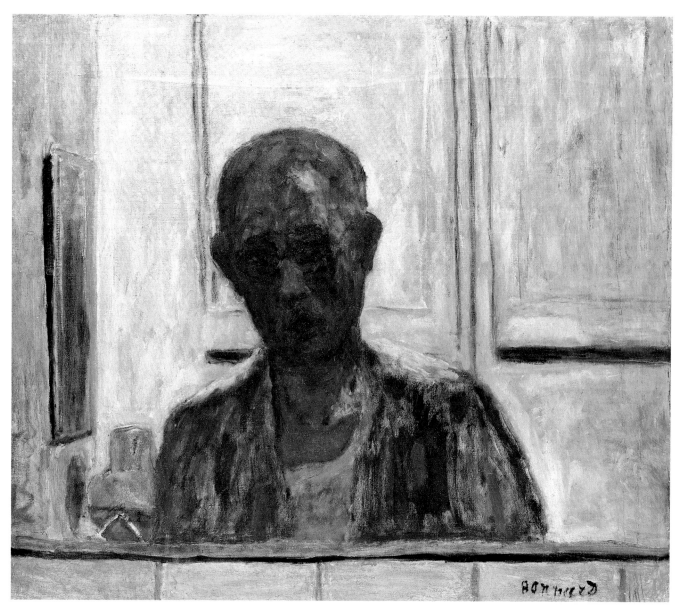

Autoportrait (Self-Portrait), 1938. (56 x 68.5 cm). Private Collection, USA.

The Studio

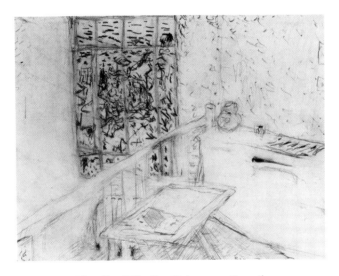

L'atelier (*The Studio*), 1932. Pencil.

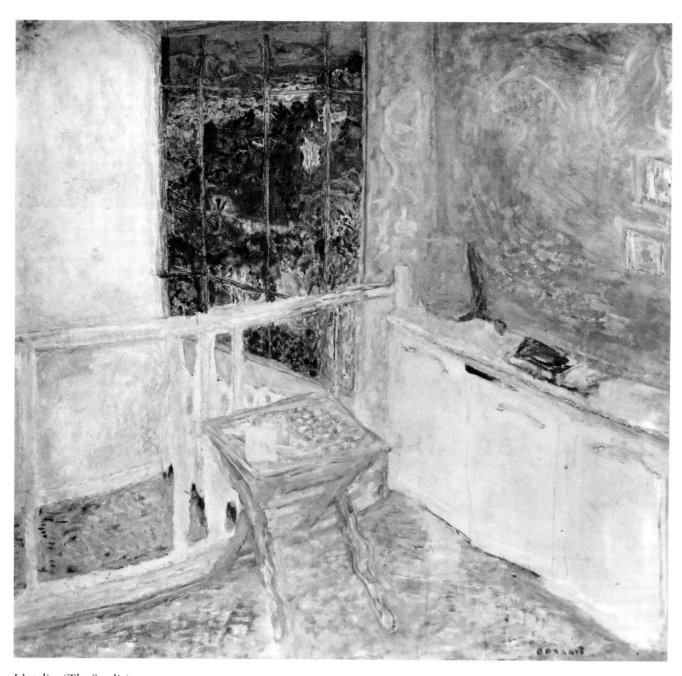

L'atelier (*The Studio*), 1932.

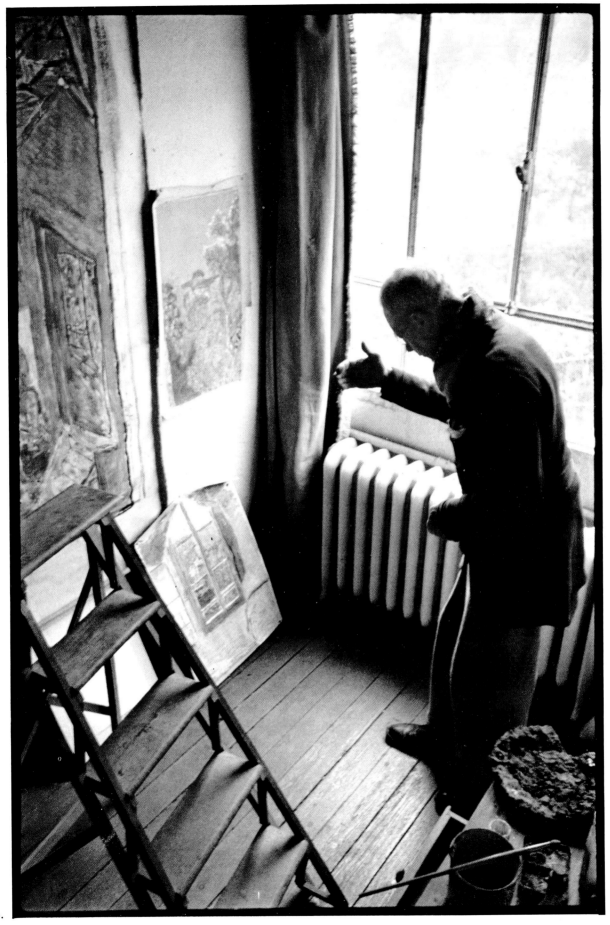

H.C.B.

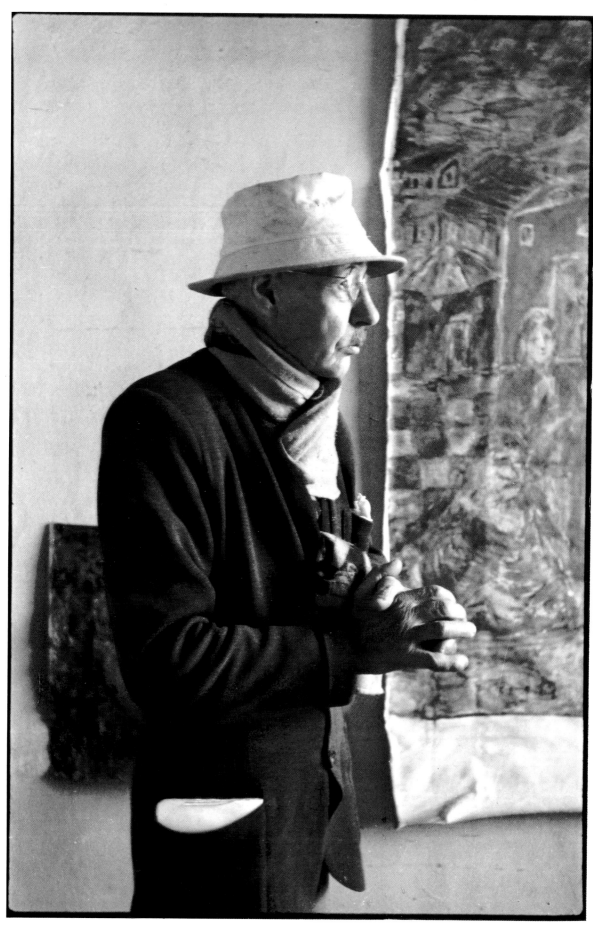

H.C.B.

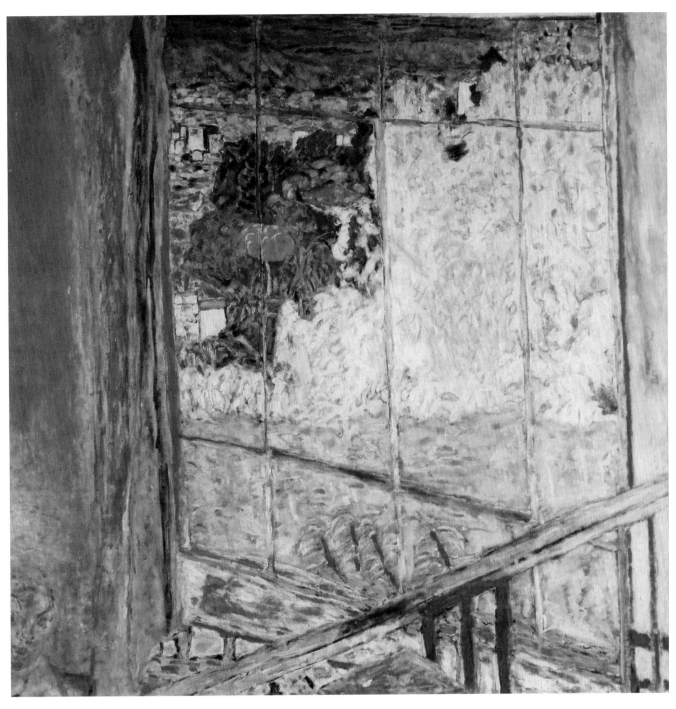

L'atelier au mimosa (*The Studio with Mimosa*), 1939. (125 x 125 cm). Musée National d'Art Moderne, Paris.

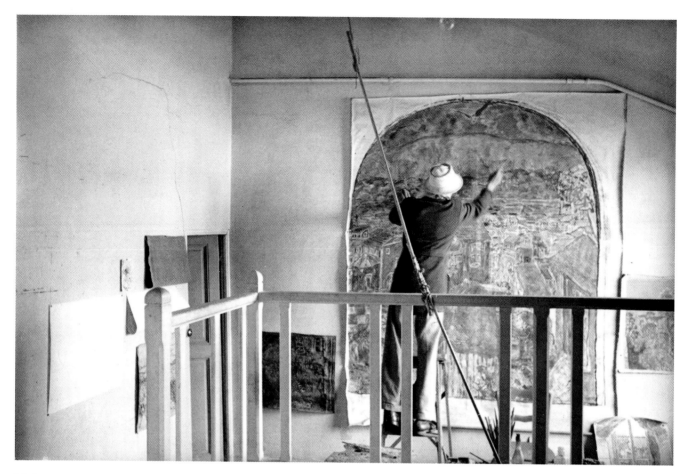

H.C.B.

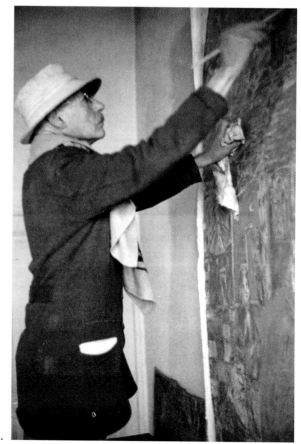

H.C.B.

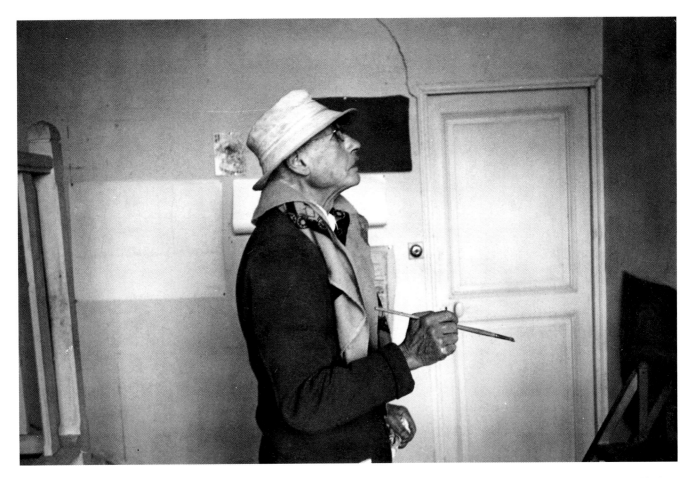

H.C.B.

In the studio in 1945 at work on *Saint François de Sales*.

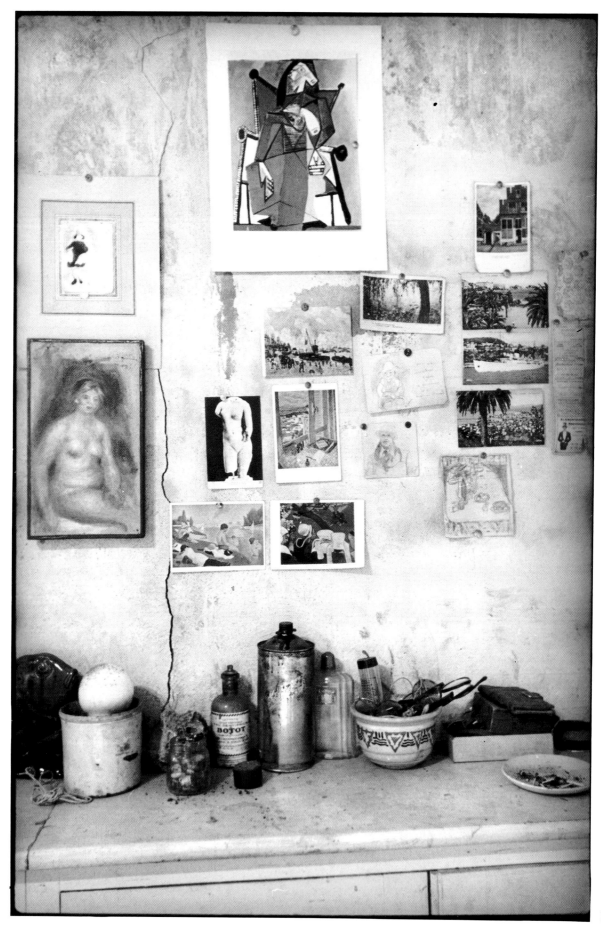

H.C.B.

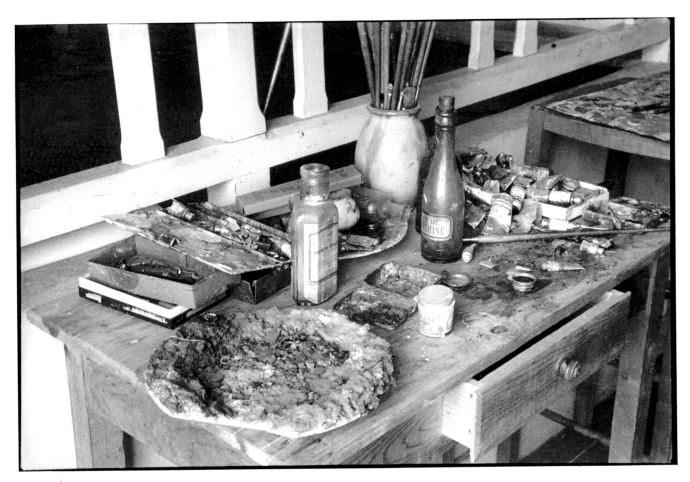

H.C.B.

In the studio. The table with the plate-palette.

The wall above the white cupboard.

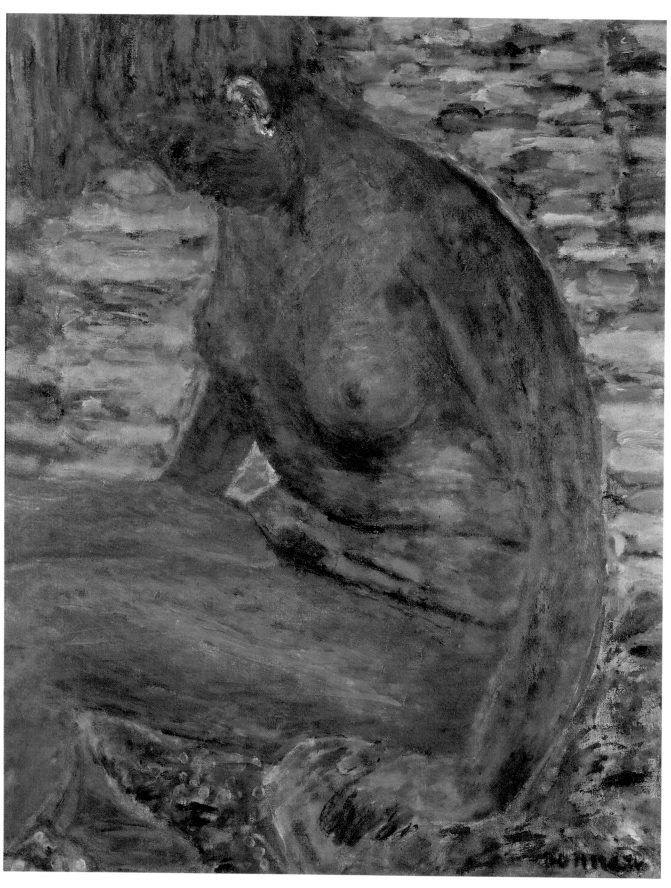

Le nu sombre (*The Dark Nude*), 1941. (81 x 65 cm). Private Collection, France. The model is Dina Vierny, who also posed for Maillol and Matisse. This, Bonnard's last nude, is one of the only ones painted in the studio.

The Self-Portraits

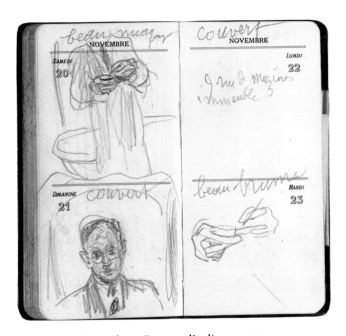

Pages from Bonnard's diary, 1937.

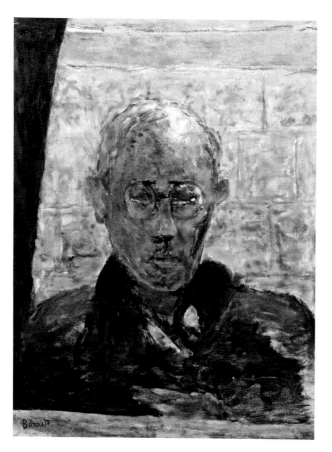

Autoportrait (Self-Portrait), 1945. (65 x 47 cm).
Private Collection, USA.

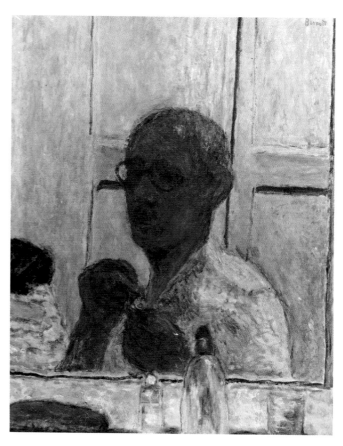

Autoportrait (Self-Portrait), *c.* 1941. (77 x 62 cm).
Private Collection, USA.

Throughout his life Bonnard painted portraits of himself.
There was never any trace of vanity or self-satisfaction
in this artist whose modesty was legendary.
Only anxiety, questioning and deep thought.
At the end of his days these interpretations, these self-examinations, grew in number.
They were indicative of great loneliness and lucidity . . .

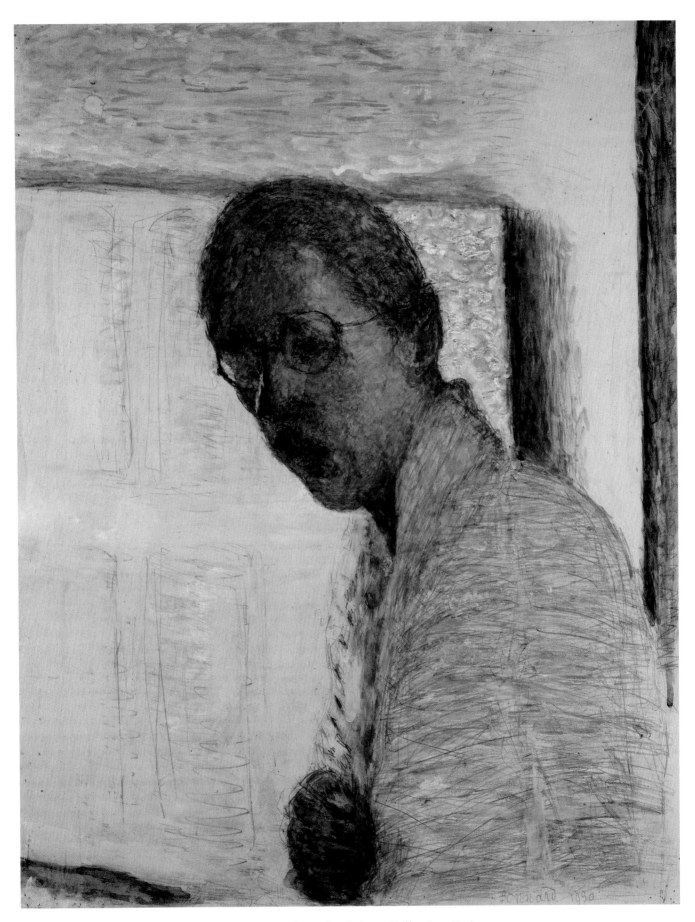

Autoportrait (*Self-Portrait*), 1930. (65 x 50 cm). Gouache. Private Collection, Paris.

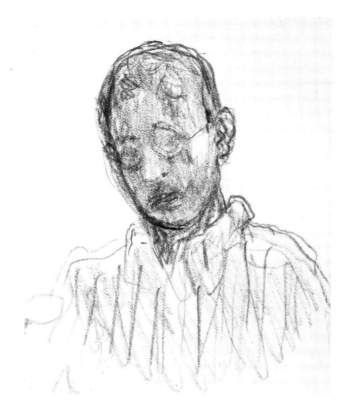

Drawing *c.* 1933. Pencil. Private Collection, Paris.

The sinister curtain is about to fall on the spectacle of the world.
The colours of sunset will give way to night
and the last patch of light will go out. The nose is pinched.
The gaze is already drawn to the abyss. Through the shadow and light,
brightness and gloom, Bonnard comes close to Rembrandt.

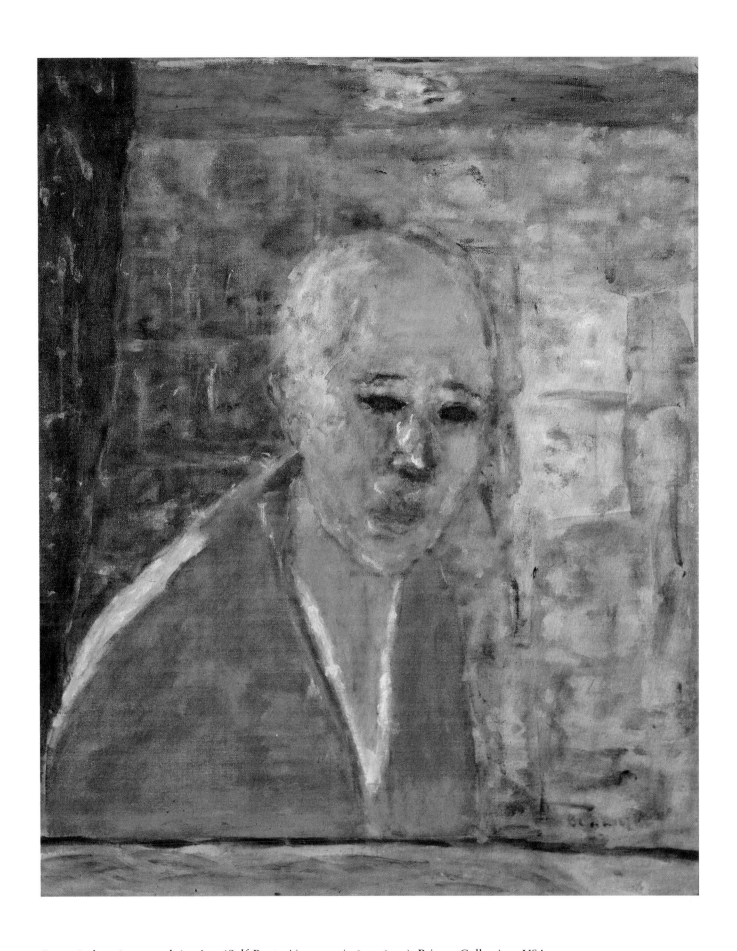

Portrait du peintre par lui-même (*Self-Portrait*), 1945. (56 x 46 cm). Private Collection, USA.

Provisional list of works painted by Pierre Bonnard
in his studio at the Villa 'Le Bosquet' at Le Cannet
between 1927 and 1947

The numbering of the paintings refers to the *Catalogue raisonné de l'oeuvre peint* by Jean and Henry Dauberville, published by Editions Bernheim-Jeune.

 The dates given refer to the time the works were begun. Dates and titles are based on the most recent research.

Landscapes	83 paintings	19 gouaches
The Garden	19 paintings	4 gouaches
The Dining Room	59 paintings	15 gouaches
The Kitchen	1 painting	–
The Staircase	1 painting	2 gouaches
The Small Sitting Room	21 paintings	8 gouaches
The Bathroom	15 paintings	6 gouaches
The Painter's Bedroom	6 paintings	2 gouaches
Spare Bedroom	1 painting	–
The Studio	11 paintings	3 gouaches

217 paintings and 59 gouaches in all. The gouaches have not yet been catalogued.

* Paintings reproduced in this book are marked with an asterisk.

Landscapes

Les murs jaunes (The Yellow Walls), c. 1927. (Dauberville 1295)

Paysage du Cannet (Landscape of Le Cannet), c. 1927. (Dauberville 1370)

Le départ pour les îles de Lérins (The Departure for the Îles de Lérins), 1927. (Dauberville 1371)

*Le port orageux. Cannes (The Stormy Harbour. Cannes), 1927. (Dauberville 1372) pp. 38/39

Vue du Cannet (View of Le Cannet), 1927. (Dauberville 1373)

Paysage au soleil couchant (Landscape at Sunset), 1927. (Dauberville 1374)

Le bois au bord de la mer (The Wood on the Seashore), 1927. (Dauberville 1375)

Le Cannet sous la neige (Le Cannet in the Snow), 1927. (Dauberville 1376)

Décor méridional (Southern Scenery), 1928. (Dauberville 1395)

Paysage au Cannet (Landscape at Le Cannet), 1928. (Dauberville 1396) – with the painter's house

Paysage. Le Cannet (Landscape. Le Cannet), 1928. (Dauberville 1397) – with the painter's house

Vue du Cannet (View of Le Cannet), c. 1930. (Dauberville 1418)

Le Cannet, c. 1930. (Dauberville 1419)

Méditerranée (Mediterranean), c. 1930 (Dauberville 1426)

Bord de mer (Seashore), c. 1930. (Dauberville 1427)

Le port de Cannes (Cannes Harbour), 1930. (Dauberville 1428)

Port de Saint-Tropez (Saint-Tropez Harbour), c. 1930. (Dauberville 1429)

La plage, mer bleue (The Beach, Blue Sea), c. 1930. (Dauberville 1436)

Marine (Seascape), Cannes, 1931. (Dauberville 1463)

Marine (Seascape), Cannes, 1931. (Dauberville 1485)

L'Esterel (The Esterel), c. 1931. (Dauberville 1571)

Le Cannet, c. 1931. (Dauberville 1574)

Bord de mer (Seashore), c. 1932 (sketch). (Dauberville 1488)

La baie (The Bay), 1932. (Dauberville 1489)

Paysage de Provence (Landscape in Provence), 1932. (Dauberville 1491)

La plage (The Beach), c. 1932 (sketch). (Dauberville 1490)

Cabanons au Cannet (Cottages at Le Cannet), c. 1933. (Dauberville 1506)

Le débarcadère (The Landing Stage), 1934. (Dauberville 1517)

La baie de Cannes (The Bay at Cannes), c. 1935. (Dauberville 1529)

La rue aux volets verts (The Street with Green Shutters), c. 1935 (sketch). (Dauberville 1531)

Bord de mer (Seashore), c. 1935. (Dauberville 1532)

Pleine mer (High Tide), c. 1936. (Dauberville 1541)

La mer à Saint-Tropez (The Sea at Saint-Tropez), c. 1937. (Dauberville 1542)

Le Golfe de Saint-Tropez (The Bay of Saint-Tropez), c. 1937. (Dauberville 1550)

Paysage au Cannet (Landscape at Le Cannet), c. 1938. (Dauberville 1560)

Bord de mer (Seashore), c. 1938. (Dauberville 1561)

L'embarcadère (The Landing Stage), c. 1938. (Dauberville 1562)

Paysage au Cannet (Landscape at Le Cannet), c. 1939. (Dauberville 1568) – with the painter's house

Paysage du Midi (*Landscape of the Midi*), 1939. (Dauberville 1569)

Le chemin jaune aux enfants (*The Yellow Path with Children*), c. 1939. (Dauberville 1570)

Citronniers au Cannet (*Lemon Trees at Le Cannet*), c. 1940. (Dauberville 1581)

Paysage au couchant (*Landscape at Sunset*), c. 1940. (Dauberville 1584)

Paysage au Cannet (*Landscape at Le Cannet*), c. 1940 (sketch). (Dauberville 1587)

Méditerranée (*Mediterranean*), c. 1940. (Dauberville 1588)

**La descente au Cannet* (*The Descent to Le Cannet*), 1940. (Dauberville 1627) – with the painter's house pp. 42/43

L'hiver au Cannet (*Winter at Le Cannet*), 1940. (Dauberville 1642) – with the painter's house

L'avenue Victoria, 1941. (Dauberville 1518)

L'avenue Victoria, 1941. (Dauberville 1533)

Paysage du Midi (*Landscape of the Midi*), c. 1941. (Dauberville 1579)

Paysage du Cannet (*Landscape at Le Cannet*), c. 1941. (Dauberville 1580a)

Paysage du Midi (*Landscape of the Midi*), c. 1941. (Dauberville 1603)

Le Cannet, 1941. (Dauberville 1604)

Les toits rouges au Cannet (*The Red Roofs at Le Cannet*), c. 1941. (Dauberville 1605) – with the painter's house

**Vue panoramique du Cannet* (*Panoramic View of Le Cannet*), 1941. (Dauberville 1606) – with the painter's house pp. 44/45

Le canal de la Siagne, 1941. (Dauberville 1615)

Paysage du Cannet sous la pluie (*The Landscape of Le Cannet in the Rain*), 1941. (Dauberville 1669)

Paysage du Cannet (*Landscape of Le Cannet*), c. 1942. (Dauberville 1578)

Paysage à la maison rouge (*Landscape with Red House*), c.

P.V.

1942. (Dauberville 1611) – with the painter's house

Maison du peintre (*The Painter's House*), c. 1942. (Dauberville 1612)

Paysage à l'oiseau bleu (*Landscape with Blue Bird*), c. 1942. (Dauberville 1613)

Amandiers en fleur, cactus et figure d'enfant (*Almond Trees in Blossom, Cactus and Figure of a Child*), c. 1942. (Dauberville 1614)

Le canal de la Siagne, c. 1942. (This will appear in the addenda to the Dauberville catalogue)

Chemin montant (*Uphill Path*), c. 1943. (Dauberville 1582)

Vue du Cannet (*View of Le Cannet*), c. 1943. (Dauberville 1625)

L'avenue Victoria c. 1943. (Dauberville 1626)

Vue de la croisette à Cannes (*View of the Croisette at Cannes*), 1944. (Dauberville 1301)

Paysage du Midi entre des arbres (*Landscape of the Midi through trees*), c. 1944. (Dauberville 1638)

Paysage aux oliviers (*Landscape with Olive Trees*), c. 1944 (study). (Dauberville 1640)

Paysage aux palmiers (*Landscape with Palm Trees*), 1944. (Dauberville 1641)

Les vagues bleues (*The Blue Waves*), c. 1944. (Dauberville 1643)

Paysage du Cannet (*Landscape at Le Cannet*), c. 1945 (sketch). (Dauberville 1580b)

Paysage (*Landscape*), 1945. (Dauberville 1648)

Paysage (*Landscape*), c. 1945. (Dauberville 1650)

La raidillon au Cannet (*The Steep Path at Le Cannet*), 1945. (Dauberville 1651) – with the painter's house

Grand paysage du Cannet (*Large Landscape of Le Cannet*), 1945. (Dauberville 1652)

P.V.

Paysage (*Landscape*), 1945. (Dauberville 1653)

**Ciel d'orage sur Cannes* (*Stormy Sky over Cannes*), 1945. (Dauberville 1654) pp. 40/41

Baigneurs à la fin du jour (*Bathers at the End of the Day*), 1945. (Dauberville 1655)

Le chemin vert et le canal (*The Green Path and the Canal*), 1945. (Dauberville 02152)

Jour de pluie au Cannet (*Rainy Day at Le Cannet*), 1946. (Dauberville 1668)

Le petit pont (*The Little Bridge*), 1946. (Dauberville 1670)

Ruelle du Midi (*Alleyway in the Midi*), c. 1946. (Dauberville 1671)

**Le raidillon vers la maison* (*The Steep Path to the House*), 1946. (Dauberville 1673) p. 46

P.V.

The Garden

**Le jardin au basset* (*The Garden with a Dachshund*), c. 1927. (Dauberville 1191) pp. 50/51

Le jardin du Cannet (*The Garden at Le Cannet*), c. 1927. (Dauberville 1192)

La petite fille au chien (*The Little Girl with a Dog*), 1929. (Dauberville 1415)

Mlle Isabelle Lecomte de Nouy, 1929. (Dauberville 1416)

L'amandier (*The Almond Tree*), c. 1930. (Dauberville 1420)

Le jardin (*The Garden*), c. 1935 (sketch). (Dauberville 1530)

**Le jardin* (*The Garden*), c. 1937. (Dauberville 1556) p. 53

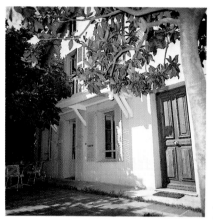

D.D.

L'escalier du jardin (*The Garden Steps*), c. 1940. (Dauberville 1583)

**L'escalier du jardin* (*The Garden Steps*), c. 1940. (This will appear in the addenda to the Dauberville catalogue) p. 48

L'amandier en fleurs (*The Almond Tree in Blossom*), 1943. (Dauberville 1585)

Le jardin (*The Garden*), c. 1943. (Dauberville 1624)

**Le jardin* (*The Garden*), 1943. (Dauberville 1649) p. 56

**Le bassin d'Agenor* (*Agenor's Pond*), c. 1943. (Dauberville 1636) p. 23

Corbeille de fruits sur la table du jardin (*Basket of Fruit on the Garden Table*), c. 1944. (Dauberville 1644)

Portrait de Colette Carré (*Portrait of Colette Carré*), 1944. (Dauberville 1646)

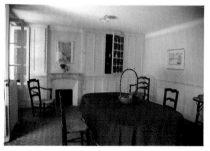

P.V.

Paysage au toit rouge (*Landscape with Red Roof*), 1945. (Dauberville 1667)

Le jardin (*The Garden*), c. 1946. (Dauberville 1672)

Midi au jardin (*Midday in the Garden*), 1946. (Dauberville 1674)

**L'amandier en fleurs* (*The Almond Tree in Blossom*), 1945, finished in 1947. (Dauberville 1692) p. 54

The Dining Room

**La salle à manger* (*The Dining Room*), c. 1927. (Dauberville 1212) p. 76

Nature morte sur une nappe à carreaux (*Still Life on a Check Tablecloth*), c. 1927. (Dauberville 1307)

Vase de fleurs avec figure (*Vase of Flowers with Figure*), 1928. (Dauberville 1400)

Corbeille de fruits (*Basket of Fruit*), 1928. (Dauberville 1401)

Fleurs sur le tapis rouge (*Flowers on the Red Tablecloth*), 1928. (Dauberville 1402)

Marthe dans la salle à manger (*Marthe in the Dining Room*), c. 1930 (This will appear in the addenda to the Dauberville catalogue)

Nature morte – raisins (*Still Life – Grapes*), 1931. (Dauberville 1466)

Nature morte aux fruits (*Still Life with Fruit*), 1931. (Dauberville 1467)

Nature morte jaune et rouge (*Yellow and Red Still Life*), 1931. (Dauberville 1469)

Le placard ou l'armoire blanche (*The Cupboard or the White Cupboard*), 1931. (Dauberville 1476)

La salle à manger du Cannet. Marthe au chat (*The Dining Room at Le Cannet. Marthe with a Cat*), 1931. (Dauberville 1503)

**Coin de salle à manger* (*Corner of the Dining Room*), 1932. (Dauberville 1496) p. 66

**La salle à manger au parasol* (*The Dining Room with a Parasol*), 1932. (Dauberville 1501) p. 77

**Marthe dans la salle à manger* (*Marthe in the Dining Room*), 1933. (Dauberville 1516) p. 59

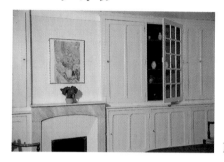

P.V.

Coupe de fruits (*Bowl of Fruit*), 1933. (Dauberville 1515)

Oranges et mandarines (*Oranges and Mandarines*), c. 1934. (Dauberville 1520)

Coin de table (*Corner of a Table*), 1935. (Dauberville 1534)

Deux corbeilles de fruits (*Two Baskets of Fruit*), c. 1935. (Dauberville 1539)

Pêches dans une assiette sur une table (*Peaches in a Plate on a Table*), c. 1935. (Dauberville 1535)

Nature morte aux fruits (*Still Life with Fruit*), 1936. (Dauberville 1545)

**Le placard rouge* (*The Red Cupboard*), 1939. (Dauberville 1511) p. 73

Corbeille et assiette de fruits sur la nappe à carreaux rouges (*Basket and Plate of Fruit on the Red Check Tablecloth*), c. 1939. (Dauberville 1575)

Marthe au chien (*Marthe with a Dog*), 1939. (Dauberville 1600)

Le dessert (*The Dessert*), 1940. (Dauberville 1589)

Nature morte au jambon (*Still Life with Ham*), 1940. (Dauberville 1590)

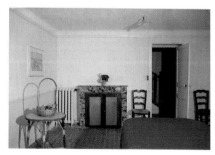

P.V.

Assiette de fruits (*Plate of Fruit*), c. 1940. (Dauberville 1591)

Oranges et kakis (*Oranges and Kakis*), c. 1940. (Dauberville 1592)

Fruits sur fond rouge (*Fruit on a Red Background*), c. 1940. (Dauberville 1593)

Les sardines (*The Sardines*), c. 1940. (Dauberville 1593)

Intérieur. La salle à manger (*Interior. The Dining Room*), 1940. (Dauberville 1635)

Avant-midi (*Morning*), 1940. (Dauberville 1676)

Nature morte. Fruits (Still Life. Fruit), c. 1942. (Dauberville 1617)

Cerises dans une assiette (Cherries on a Plate), c. 1942. (Dauberville 1618)

Panier de pêches (Basket of Peaches), 1942. (Dauberville 1619)

Nature morte à la bouteille (Still Life with Bottle), 1942. (Dauberville 1620)

Nature morte à la bouteille de vin rouge (Still Life with Bottle of Red Wine), 1942. (Dauberville 1621)

La salle à manger (The Dining Room), 1942. (Dauberville 1682)

Pêches dans une assiette (Peaches on a Plate), c. 1943. (Dauberville 1608)

Plat de pêches (Dish of Peaches), c. 1943. (Dauberville 1609)

Roses, 1943. (Dauberville 1628)

Nature morte au citron (Still Life with Lemon), 1943. (Dauberville 1629)

Nature morte aux bouteilles (Still Life with Bottles), 1944. (Dauberville 1596)

Nature morte (Still Life) (sketch). (Dauberville 1597)

* *Coupe et corbeille de fruits (Bowl and Basket of Fruit)*, 1944. (Dauberville 1607) pp. 68/69

Pêches et raisins sur nappe rouge (Peaches and Grapes on Red Tablecloth), c. 1944. (Dauberville 1631)

Corbeille de figues blanches (Basket of White Figs), c. 1944. (Dauberville 1632)

Plat de pêches (Dish of Peaches), c. 1944. (Dauberville 1633)

Le dessert (The Dessert), c. 1944. (Dauberville 1634)

* *Bouquet de mimosas (Bunch of Mimosa)*, c. 1945. (Dauberville 1656) p. 63

Les pivoines (The Peonies), 1945. (Dauberville 1657)

* *Vase de fleurs (Vase of Flowers)*, 1945. (Dauberville 1658) p. 70

Corbeille de fruits (Basket of Fruit), c. 1945. (Dauberville 1659)

Nature morte aux pêches (Still Life with Peaches), 1945. (Dauberville 1660)

Cerises (Cherries), 1945. (Dauberville 1661)

* *Corbeille de fruits dans le placard rouge (Basket of Fruit in the Red Cupboard)*, 1945. (Dauberville 1681) pp. 74/75

Portrait de Mlle Renée Terrasse (Portrait of Mlle Renée Terrasse), 1945-46. (Dauberville 1683)

Roses, c. 1946. (Dauberville 1678)

* *Corbeille de fruits (Basket of Fruit)*, c. 1946. (Dauberville 1679) p. 71

Fruits (Fruit), 1946. (Dauberville 1680)

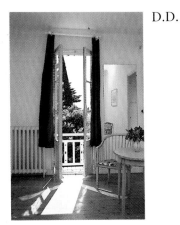

D.D.

The Small Sitting Room

Renoncules au vase bleu (Buttercups in a Blue Vase), c. 1927. (Dauberville 1311)

Fleurs (Flowers), c. 1927. (Dauberville 1353)

Fleurs rouges (Red Flowers), 1927. (Dauberville 1378)

* *La porte-fenêtre avec chien (The French Windows with Dog)*, 1927. (Dauberville 1379) p. 81

Fleurs sur la cheminée et personnage (Flowers on the Mantelpiece and Figure), 1927. (Dauberville 1385)

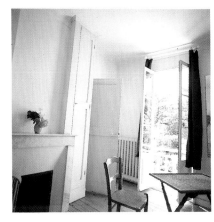

D.D.

* *L'intérieur blanc (The White Interior)*, 1929. (Dauberville 1497) pp. 84/85

* *La porte-fenêtre ou matinée au Cannet (The French Windows or Morning at Le Cannet)*, 1929. (Dauberville 1499) pp. 82/83

Deux vases de fleurs (Two Vases of Flowers), c. 1930. (Dauberville 1439)

Fleurs dans un vase (Flowers in a Vase), c. 1930. (Dauberville 1441)

Bouquet de mimosa (Bunch of Mimosa), c. 1930. (Dauberville 1442)

Le pot provençal (The Provençal Pot), 1930. (Dauberville 1443)

Fleurs, pot rouge et vert (Flowers, Red and Green Pot), 1930. (Dauberville 1444)

Lilas mauve (Mauve Lilacs), 1930. (Dauberville 1445)

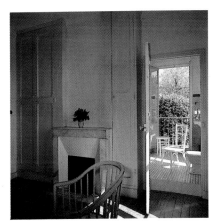

D.D.

Fleurs sur la cheminée (Flowers on the Mantelpiece), 1930. (Dauberville 1449)

* *Vase de fleurs sur la cheminée (Vase of Flowers on the Mantelpiece)*, 1930. (Dauberville 1450) p. 89

Le petit déjeuner (The Breakfast), 1930. (Dauberville 1455)

Le goûter (The Tea), 1931. (Dauberville 1474)

* *Le petit salon et la salle de bains (The Small Sitting Room and the Bathroom)*, 1932. (Dauberville 1512) p. 90

Le bouquet de roses (The Bunch of Roses), c. 1936. (Dauberville 1544)

Le thé (Tea), 1936. (Dauberville 1549)

La cafetière (The Coffee Pot), c. 1937. (Dauberville 1557)

The Bathroom

*Nu debout (Standing Nude), 1928. (Dauberville 1406) p. 92
*Le nu gris (The Grey Nude), 1929. (Dauberville 1548) p. 93

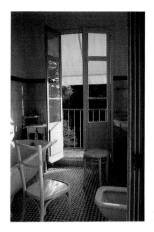

P.V.

Nu au gant de crin (Nude with Massage Glove), 1930. (Dauberville 1504)
*La sortie de la baignoire (Getting out of the Bath), c. 1930. (Dauberville 1364) p. 95
Nu aux babouches rouges (Nude with Red Babouches), 1932. (Dauberville 02172)
*La toilette (The Toilette), c. 1932. (Dauberville 1505) p. 97
*Le nu à la baignoire (The Nude in the Bath), 1937. (Dauberville 1566) pp. 98/99
La grande baignoire (The Large Bathtub), 1937. (Dauberville 1566)
Le gant de crin (The Massage Glove), 1937. (Dauberville 1623)
Nu accroupi (Crouching Nude), 1938. (Dauberville 1602)
Dans la salle de bains (In the Bathroom) (sketch). (Dauberville 1598)
Nu dans le bain au petit chien (Nude in the Bathroom with a Little Dog), 1940. (Dauberville 1687)
Nu au basset (Nude with a Dachshund), 1941. (Dauberville 1665)
*Autoportrait (Self-Portrait), 1945. (Dauberville 1662) p. 116
*Portrait du peintre par lui-même (Self-Portrait), 1945. (Dauberville 1663) p. 119

The Painter's Bedroom

Autoportrait. 'Le boxeur' (Self-Portrait. 'The Boxer'), 1931. (Dauberville 1475)
Autoportrait (Self-Portrait), 1933. (Dauberville 1513)

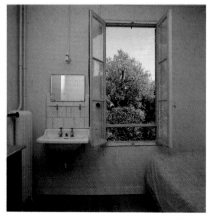

D.D.

*Autoportrait (Self-Portrait), 1938. (Dauberville 1565) p. 104
*Autoportrait (Self-Portrait), 1941. (Dauberville 1599) p. 116
Autoportrait (Self-Portrait), c. 1942. (Dauberville 1664)
*La petite fenêtre (The Little Window), 1946. (Dauberville 1675) p. 103

Spare Bedroom

Fenêtre ouverte (Open Window), 1940. (Dauberville 1586)

The Kitchen

Ustensiles de cuisine (Kitchen Utensils), 1946. (Dauberville 1683)

The Staircase

*La robe rouge (The Red Dress), 1927. (Dauberville 1381) p. 78

The Studio

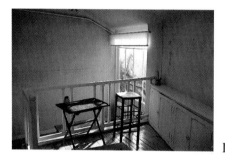

P.V.

Nu au radiateur (Nude with a Radiator), 1928. (Dauberville 1405)
Nu (Nude), 1931. (Dauberville 1482)
Nu assis (Seated Nude), 1931 (study). (Dauberville 02171)
*L'atelier (The Studio), 1932. (Dauberville 1498) p. 106
*L'atelier au mimosa (The Studio with Mimosa), 1939. (Dauberville 1677) p. 109
*Le nu sombre (The Dark Nude), 1941. (Dauberville 1686) p. 114
Portrait de Gisèle Belleud peignant (Portrait of Gisèle Belleud Painting), 1942. (Dauberville 1647)
Saint François de Sales, 1942. (Dauberville 1666)
Portrait de Gisèle Belleud (Portrait of Gisèle Belleud), c. 1943. (Dauberville 1622)
Les sardines (The Sardines), c. 1944 (Dauberville 1645)
Figure joviale (Jovial Face), 1946. (Dauberville 1685)

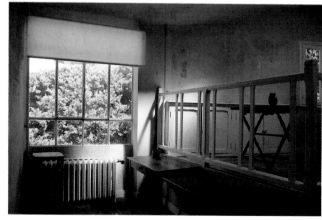

P.V.

Photo Credits

for Pierre Bonnard's works:

Archives Bernheim-Jeune: 48
Archives Hahnloser, Fribourg (Switzerland): 12
Bernheim-Jeune, Paris: 46, 76, 77, 78, 90, 92, 106, 115
Bulloz: 53, 98/99
A. Danvers, Bordeaux: 117
Fondation Septentrion, Marcq-en-Bareuil: 70
Galerie Beyeler, Basle: 74/75, 89, 93
Galerie Huguette Bérès, Paris: 86/87
Galerie Schmit, Paris: 36
Basil Goulandris: 95
Laurent Sully-Jaulmes: 2, 6, 14, 16, 17, 19, 22, 23, 33, 40/41, 48, 56, 57, 91, 96, 98, 100, 103, 105, 114, 117
Musée National d'Art Moderne, Centre Georges Pompidou, Service de documentation photographique: 54, 66, 109
Musée de Peinture et de Sculpture de Grenoble/I.F.O.T.: 84/85
Henri Screpel: 58
The Art Institute of Chicago: 64/65
The Metropolitan Museum of Art, New York: (BEQUEST OF SCOFIELD THAYER, 1984) 10; (Robert Lehman Collection, 1975) 42/43
The Phillips Collection, Washington, D.C.: 35
The National Gallery of Canada, Ottawa: 38/39
The Reader's Digest Association, Inc., Pleasantville, N.Y.: 71
Ville de Lyon, Musée des Beaux-Arts/Studio Bernard Lontin: 59

For other illustrations:
Henri Cartier-Bresson (H.C.B.): 26, 47, 52, 55, 60/61, 62, 80, 107, 108, 110, 111, 112, 113
Denise Demarziani (D.D.): 124, 125, 126
Claude Frossard: 21, 27, 29
Bernard Joly and Jacky Kargayan: 28, 29, 30
André Ostier: 18, 32
Pierrette Vernon (P.V.): 31, 122, 123, 124, 126

All rights reserved for illustrations for which no source is given.

References

The principal sources of information used in writing this book were:
– *Catalogue raisonné de l'œuvre peint* by Jean and Henry Dauberville, published by Bernheim-Jeune;
– the archives of my family;
– and the diaries of Pierre Bonnard. These diaries go to the very heart of the artist's work and merit a study and publication in their own right.

Acknowledgments

We are very grateful to all those who have helped us in the production of this book, and in particular to:

Mme Huguette Bérès, Dr Claude Bergogne, M. Claude Bernard, M. Ernst Beyeler (Basle), Mmes Aline and Marguerite Bowers, Mme René Collamarini, MM. Guy-Patrice and Michel Dauberville, M. Philippe Durey (Musée des Beaux-Arts, Lyons), M. Gallimard, M. Basil Goulandris, Dr and Mme Paul Hahnloser (Fribourg, Switzerland), Mrs Colta Ives (Metropolitan Museum of Art, New York), Mme Louis Lepoutre, M. Philippe Levantal, Mlle Elizabeth Naud, Mrs Sasha Newman (The Phillips Collection, Washington, D.C.), M. and Mme Albert Prouvost, M. Manuel Schmit, M. Henri Screpel, M. Toni Stooss (Kunsthaus, Zurich), M. Patrice Trigano, M. Daniel Wildenstein.

The author wishes to thank Mme Yvonne Jestaz for improvements to his manuscript.

As a mark of his admiration for Pierre Bonnard, Henri Cartier-Bresson has provided the photographs he took in 1945 in Bonnard's house at Le Cannet. We are profoundly grateful to him.